DRAW

Caricature

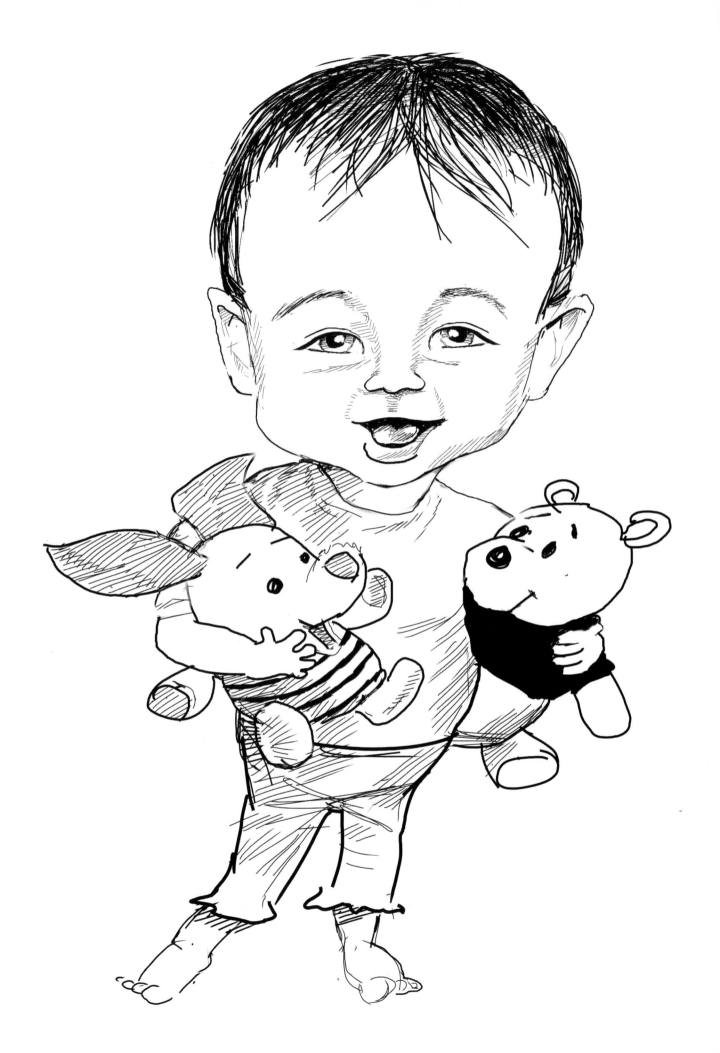

DRAW
Caricature

Steve Chadburn • Noel Ford • Pete Dredge

NEW
HOLLAND

First published in 2007 by New Holland Publishers (UK) Ltd
London • Cape Town • Sydney • Auckland

Garfield House
86–88 Edgware Road
London W2 2EA
United Kingdom
www.newhollandpublishers.com

80 McKenzie Street
Cape Town 8001
South Africa

Level 1, Unit 4
14 Aquatic Drive
Frenchs Forest
NSW 2086
Australia

218 Lake Road
Northcote
Auckland
New Zealand

10 9 8 7 6 5 4 3 2 1

ISBN 978 1 84537 675 8

Senior Editor: Corinne Masciocchi
Designer: Adam Morris
Editorial Direction: Rosemary Wilkinson
Production: Hazel Kirkman

Reproduction by Pica Digital PTE Ltd, Singapore
Printed and bound by Times Offset, Malaysia

CONTENTS

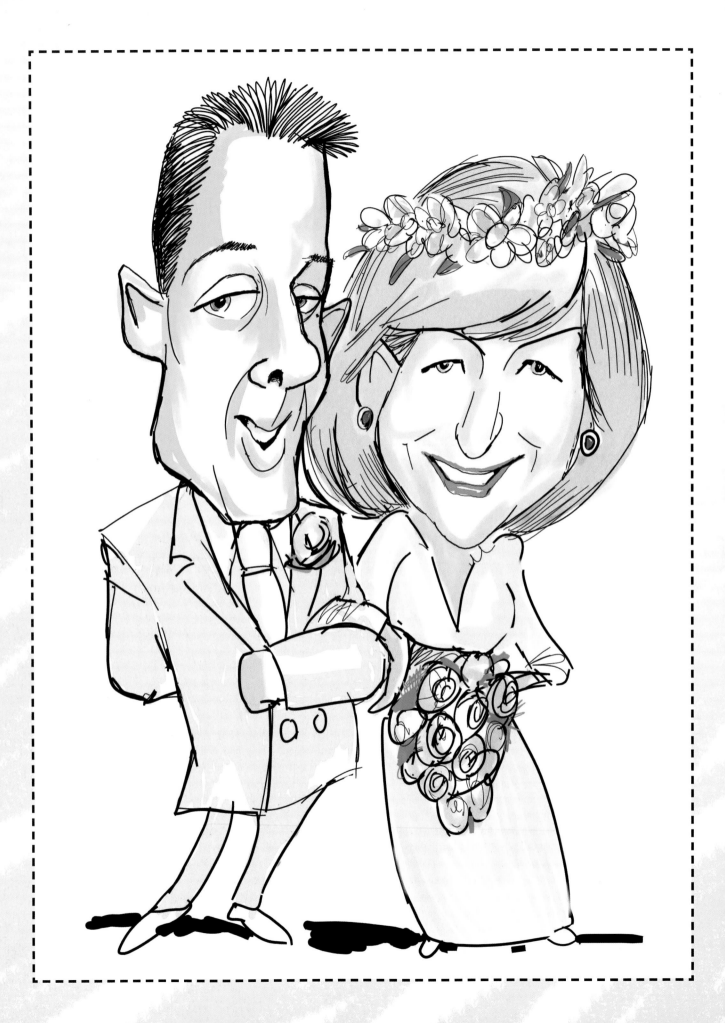

INTRODUCTION

The ability to caricature is something to treasure. It doesn't matter whether you want to do it just for fun or with a view to selling your work, there is something about the art that people love. Just watch a group of people looking on whilst someone is having their caricature drawn and you will see what we mean. A caricaturist will often find him or herself the centre of attention at parties and gatherings.Of course, if you want to caricature, you don't have to do it in public! Just as much pleasure can be found (and given) from work done in the privacy of your own home. So if you have an urge to caricature, be it purely for your own pleasure and that of your friends and family, for profit, or for a little bit of both, read on.

Many people make the understandable mistake of assuming that just because someone can draw cartoons, they can draw caricatures. However, cartooning and caricaturing, though they share some common ground, are two separate skills. For a cartoon to be successful, it must be funny or whimsical but for a caricature to work, it must capture the essence of the person being caricatured. As you will learn in the following pages, this entails a lot more than simply producing a basic photographic likeness.

Some may tell you that caricature is a talent you are born with, but this is untrue. Whilst it is advantageous to have a natural talent, it isn't a prerequisite to learning to draw good caricatures. By a happy coincidence, we, the authors of this book, happen to represent three distinct types of caricaturist:

Steve is one of those lucky ones, with a natural aptitude for caricature.

Pete is a successful cartoonist but not a natural caricaturist. He discovered he had a knack for the skill and set to work developing it until, today, caricature is an important element of his work.

Noel, another successful cartoonist, is certainly not a born caricaturist and, although he has searched long and hard, has so far failed to find any hidden knack. He realized, however, that the ability to caricature was going to be a very necessary tool of his cartooning trade and was determined to master it.

Allow us, then, to introduce ourselves...

Steve Chadburn

I have the good fortune to fall into the category of those with a natural aptitude for caricature. I began my cartooning career in the comics and children's illustration business and I assumed, at the time, that all professional cartoonists could caricature as a matter of routine. It was the look of alarm and the step backwards from some of my colleagues when the subject of caricature came up, that gave me the clue that things might not be as I supposed!

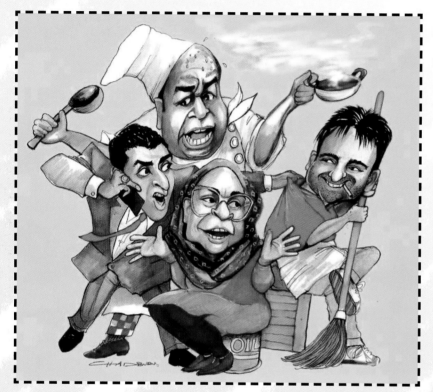

Having an eye for caricature has been both a blessing and a small inconvenience. Having a natural ability, I specialized in caricature for many years, both in the publishing and corporate markets. I must have drawn tens of thousands of instant portraits, travelling all over the world for corporate events, allowing me to hone my caricature skills and fine-tune the antenna I rely on when observing my subjects.

And the small inconvenience? In addition to caricature, I do a lot of studio illustration work and my hectic schedule means working long and strange hours. Of course, I still do a lot of caricature work in the studio, too, producing work for both publication and presentation, sometimes working from photographs and, on occasion, taking advantage of the available technology and drawing 'live' over a computer video-link.

If asked to name the greatest challenge to producing a good caricature, I would say that it is to go beyond physical likeness and bring out the personality of the sitter. This isn't always as straightforward as it sounds, though, so don't get too upset if you don't get it right first time around. It takes time and effort to perfect the art of caricature, so if at first you don't succeed, try, try again!

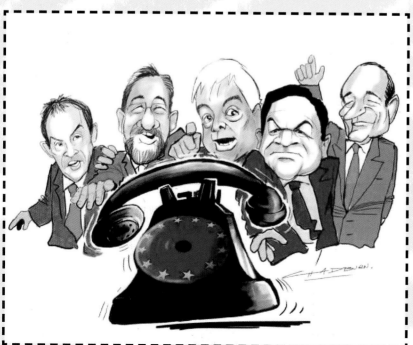

Pete Dredge

I started out as a gag cartoonist and still regard this skill as the bedrock for all my other cartoon output, be it strip cartoon, editorial comment, daily topical features or advertising and PR.

However, many years ago as an art student, I developed the knack of caricaturing, from memory, tutors and fellow students for my own amusement and that of my friends. I found I could capture, facially and in posture, the essence of a person's character, and although not too detailed or strictly accurate, my drawings were instantly recognizable.

As my cartoon career flourished I would get occasional requests for caricatures for gifts or presentations. Even working from photographs, it would take me several attempts before I was reasonably happy with my efforts. This wasn't a problem, as the time taken to produce these caricatures in the comfort of my studio wasn't an issue and the recipient was always delighted with the artwork. The same working methods were employed when producing caricature work for print and publications although the deadlines did become tighter! At this stage, I never considered tackling live caricature, mainly because of a lack of confidence in my ability to get it right first time and a fear of failing in public!

I eventually overcame this hurdle by plunging, not exactly into the deep end but certainly into the safer, shallower depths of free caricaturing at charity events and cartoon festivals. Drawing for no charge to the sitter took the pressure off and I found that the more I practised, the more accomplished I became. I now regard caricaturing as another string to my professional bow and, though not my major strength, I no longer shudder at the prospect of drawing live caricatures.

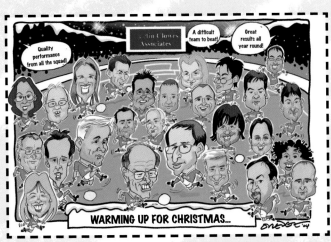

Noel Ford

Like Pete, I began my cartooning career as a gag cartoonist. This was my major strength and speciality and it has proven useful in developing my work into a much broader field. Nowadays, my work comprises editorial comment and illustration, humorous illustration, advertising, greeting cards and corporate cartooning, to name but a few.

I definitely fall into the category of reluctant caricaturist! I don't think, at the beginning of my career, that I had the slightest natural aptitude for caricature, but I soon discovered that it was something I would have to tackle if I was to progress. My work as an editorial cartoonist for a national UK newspaper (and also, on occasion, my work for a satirical magazine) demanded that I be able to caricature both politicians and celebrities and I also received a lot of requests from clients to produce caricatures for corporate presentation. I was, to put it simply, thrown in at the deep end.

Because I lacked any natural caricaturing ability, I had to learn the hard way, studying photographs and even sometimes tracing them in order to simplify the face into a few lines so that I could see more easily the features (if only I'd had a book like this one to help me!).

Nowadays, caricaturing comes more easily to me and I don't approach this sort of work with the trepidation I used to, though I don't think I'd have the nerve to do live caricature work the way my fellow authors do! The way I taught myself to caricature still shows in my work today, however. As you can see, from the examples below, my caricature style is much less exaggerated than the styles of many specialist caricaturists.

Using this book

The first thing to think about is which materials are the best for caricaturing. There is no definitive answer to this question – some materials suit some people better than others. It is a good idea to experiment as much as you can to find those that most suit you. This is important because your choice of drawing implement will almost certainly influence your style.

First, then, we will introduce you to some of the most common choices. To help you, we'll also explain some of the advantages and disadvantages of individual materials.

The next step is to look at sources of reference. Caricatures are most often drawn from life or from photographs, and it is crucial that you are seeing your subject properly. Quite often a subject will pose in an atypical way, or a photograph may fail to reveal an important aspect of the person. Getting your source of reference right is vital to the success of your caricature because if the reference isn't right, the caricature won't be right either.

Next comes a close look at the key elements in a caricature: the eyes, the nose and the mouth. Using these three elements alone, a good caricaturist can achieve a recognizable likeness. Get these right and you are well past half-way to a successful drawing.

What is a caricature?

Before we set off on this fascinating journey of discovery, it is probably a good idea to define our subject. The problem is, that like any form of artwork, it is subjective in nature and open to wide interpretation. This is demonstrated by the fact that just about every professional practitioner of the art further expands or obscures (depending on your point of view) the subject with their own unique style. Some caricaturists will simply redefine a photographic likeness, reducing it to a symbolic, simplified line format whereas, at the other extreme, others will gleefully distort and exaggerate every feature of their subject.

The term impressionism already defines a category of fine art but it could very adequately be used to define caricature, too. A caricature is, after all, an impression of the subject as observed at that time, drawn in such a way that elements of the individual are exaggerated to make the persona more distinct. It is possible that when we look at another individual, we activate a sort of recognition programme in the brain, that instantly analyzes their features and recognition points and either matches them to the data already held on file or creates a new file entirely. Every face has a number of key lines

that are crucial to this process. The skilled caricaturist can, through practice, pick up on these recognition points instantly and base a portrait around them. The fun part is that these key lines or recognition points vary from individual to individual.

We will take you through this process in detail and let you observe the skilled caricaturist at work, going through every aspect of the portraits and demonstrating how the artists make decisions that bring their work to life, allowing them to produce a true caricature.

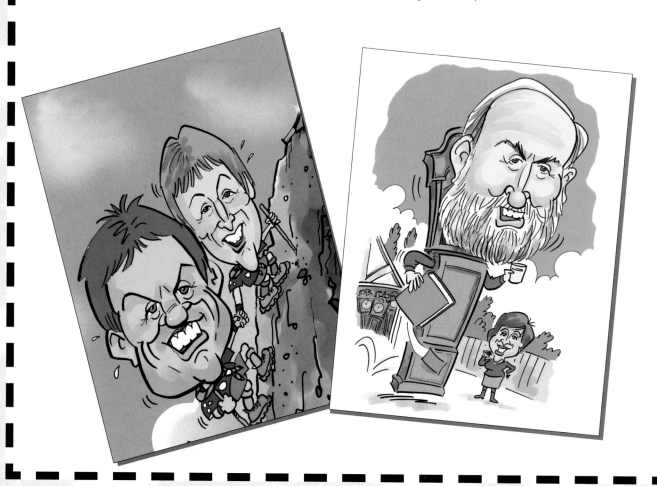

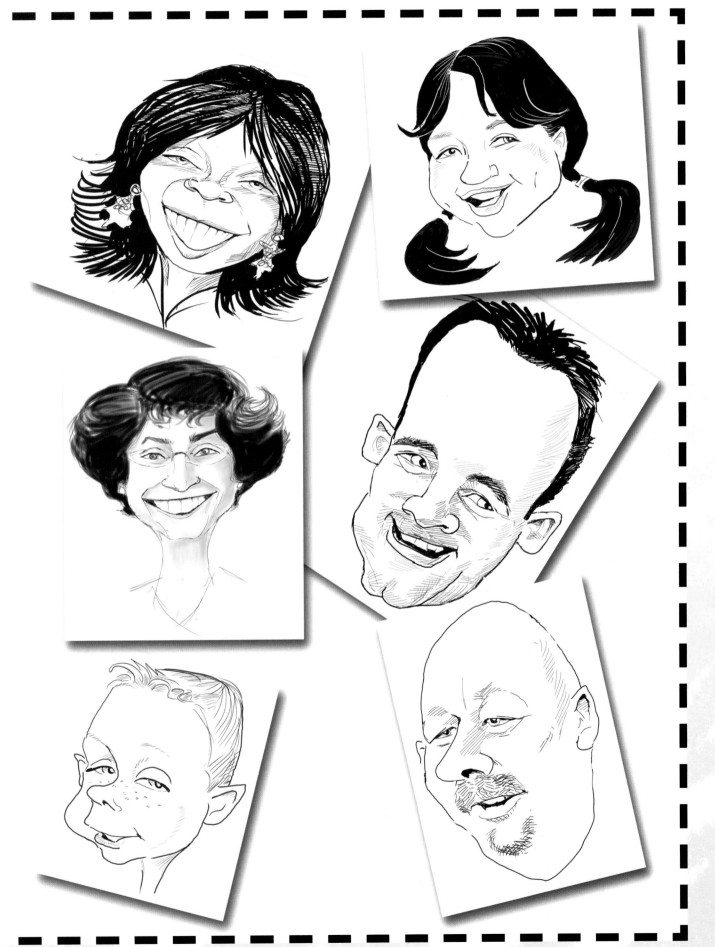

CHOOSING YOUR MATERIALS

Before we start drawing, we need to decide which are the best materials to draw caricatures with and on. The problem is that whichever caricaturist you ask, you are likely to get a different answer, and the reason for this is that some materials suit some people but not others.

There are a few basic requirements that need to be met by your materials, however, so we shall describe some of the most common ones and explain why they may or may not be suitable for you to caricature with. Some materials lend themselves best to studio working whilst others work better in a live caricature situation. We use the terms studio and live very loosely at this early stage! By studio, we mean anything from working at a drawing board to a kitchen table; and by live, we mean anything from a big corporate event to drawing caricatures at a house party. Let's begin with the paper that you will be drawing on.

Paper

The process of learning to caricature will almost certainly involve the use of a great deal of paper and we would recommend that you start off by buying a ream (that's a pack of 500 sheets) of ordinary inkjet paper. This is very cheap and readily available at stationery stores. Because it is economical to buy, you don't have to worry about making mistakes and having to start over. As you improve and are drawing caricatures to be given to people, you can progress to a better quality paper – but still buy it by the ream for the sake of economy.

For all of the above reasons, inkjet papers are excellent for studio working. Live working often involves moving around a lot and working standing up. This sort of paper can be used for working in this way, too, providing you use a clipboard so that you have a firm drawing surface.

For live caricaturing, you could also use a pad of paper, which has a firm board back, but don't buy anything expensive (like cartridge paper) at this stage. Pads of cheap paper can often be found in the children's sections of stores – just make sure, though, that the paper is white and of a reasonable quality (coloured papers are sometimes used by caricaturists but the technique requires skill and experience which you will eventually develop from learning to work, initially, on white paper). On the whole, we recommend you go for a ream of cheap inkjet paper.

Pencils, pens, brushes and others

So, now we have something to draw on but what shall we draw with? Although general cartooning and caricaturing share a lot of common ground, caricatures tend to be larger scale than a normal cartoon, often with one face taking up a whole page. Cartoons are often drawn with the intention of them being printed, on a small scale, whereas caricatures are more often intended as a piece of finished artwork to be framed, hung on a wall, or to give to the subject as a gift.

Because of this difference in scale, some drawing materials, which we wouldn't recommend for cartooning, are eminently suitable for the broad canvas of the caricature. Let's start with pencils.

Pencils

The pencil, in capable hands, is an excellent drawing medium for caricature. Bear in mind though, that pencil is a much lighter medium than ink and many people make the mistake of overworking a pencil drawing in an attempt to achieve a more substantial result. If you would like to work in pencil we recommend you choose one with a fairly soft lead, such as a 2B and certainly nothing harder than HB.

The pencil is also very useful for what we call roughing out. This is a procedure where you roughly pencil in the basic caricature and then use ink, over the pencil, to finish off. After inking (and waiting for the ink to dry

completely!) you can carefully erase the pencil line. This is a very useful procedure, especially for the beginner, because it allows you to get things right before committing to the finished drawing. Drawing directly in ink does not allow for any mistakes. If you do use a pencil to rough out, use a very soft lead and keep the lines light for easier erasing.

One final word on pencils. If you want to print out your caricature (say, to make a greetings card or to give copies to different people) or if your caricature is going to be published, generally speaking, pencil will not reproduce as well as ink.

Dip pens and India ink

The dip pen (using India ink) is still the preferred medium of many cartoonists and caricaturists. It is a medium that will give you a very strong and flexible black line, allowing strokes that go smoothly from narrow to broad in a single sweep of the nib. It is this variability of stroke width that makes it a medium that will influence your style more, probably, than any other.

Despite its popularity with many, the dip pen is also loathed by many, too – and even for those who love it, it can be something of a love-hate relationship. It can certainly be a treacherous medium – if the nib catches even slightly in the weave of the paper, a horrible ink splatter can result. Heavy ink deposits, which smudge easily, are another problem. Despite its apparent simplicity, using a dip pen and India ink is not an easy technique to master. If you want to use this medium for caricature then you should use it only for studio work and definitely not for live caricature. Moving around with an open bottle of ink is an accident waiting to happen!

disposable fountain pens can be found in many art materials and stationery stores. One word of warning: With a fountain pen, you are still working with wet ink, which is easy to smudge!

Paintbrushes

Using a paintbrush with India ink is very similar to using a dip pen with regard to the advantages and disadvantages (although you do avoid the big problem of ink splatter with a brush). As with dip pens, the brush is a very effective tool for caricature, but only in skilled hands. The technique is not an easy one and we would not recommend using brushes for caricature unless you are already familiar with them for drawing generally.

If you are already familiar with the use of brush and ink and wish to experiment with this technique in caricature, make sure to use a good quality brush, ideally sable. Sable brushes are well worth the extra expense and you will avoid the irritation of having bristles come adrift onto your drawing, as often happens when using cheaper brushes.

Fountain pens

The fountain pen is a very practical alternative to the dip pen, although the nib won't give you the same amount of variability. The advantage of a fountain pen is that it holds a good supply of ink so that, unlike a dip pen you don't have to keep... well... dipping! The downside of a fountain pen is that you must never use waterproof ink. If you do, the pen will quickly clog up. Fountain pen inks tend to be less dense than waterproof drawing inks, which means your black lines won't be as black. However, if you look hard in some art materials stores (or search the Internet), it is possible to find very black, non-waterproof drawing inks that are made especially for use in fountain pens. You may think that a fountain pen good enough to draw with will be rather expensive but this is not necessarily the case. There are many suitable fountain pens available at low cost. The important thing is to ask to try them out in the store so that you are sure you are choosing one with the best type of nib for you. You might also want to try out something called an art pen, which is similar to a fountain pen and comes with cartridges of drawing ink, or even a disposable fountain pen, non-refillable and with a self contained ink supply. However, do make sure that the ink is a good, dense, black. Art pens and

Brush pens

As the fountain pen is to the dip pen, so is the brush pen to the paintbrush. If you like the sweeping style of the paintbrush with all that lovely variability in line thickness, then the brush pen is for you.

The biggest disadvantage of the brush pen is the self-contained ink supply – quite often the ink is not of the highest quality. If you try a few out, though, you should be able to find one with a good enough dense black ink. Once the pen runs out of ink, you simply throw it away and start with a new one. This is okay, because brush pens are quite inexpensive. The big advantage of the brush pen is that the ink dries almost instantly.

Fibre-tip pens

Fibre-tip pens are a great favourite of the professional caricaturist. The self-contained, quick-drying ink makes them very suitable for caricature work, especially quick-caricature. As with brush pens, make sure you use one with a dense black ink. The main disadvantage with a fibre tip is that it wears out quickly and you may need to switch pens before the ink has actually run out. That's not a big problem, however, since these pens, like brush pens, are reasonably cheap.

Erasers

The eraser is not normally regarded as a drawing tool, of course, although it can be quite useful, when drawing in pencil, for lightening areas of the drawing and providing highlights. If you use a pencil for roughing out, however, you will definitely need a good eraser.

Any erasing will damage the paper to a certain extent so choose a good quality soft eraser. To minimize the effect of using an eraser on the paper, try to think ahead when pencilling, using as little as you can manage and keeping the strokes light.

As we already mentioned, make absolutely sure that any ink is dry before using the eraser. This cannot be emphasized enough – it's a mistake that even hardened professionals make from time to time!

Other materials to try – or not!

Where drawing materials are concerned, we have only touched the surface and there are many others that you might try. Charcoal, crayon and pastels are nice to use, but we would recommend you master the pen or pencil before moving on to these.

Pens to avoid include technical pens, which give a completely inflexible line and are liable to clogging. Ballpoint and rollerball pens are not particularly good either, though the latter are used by some.

Try as many different types of drawing materials as you can but, as you commence working through this book, we would suggest you start with something simple, such as a fibre-tip pen.

To this end, please take the above as a guide only. Some materials will suit some people better than others, and even those materials we don't recommend can be effective in the right hands.

Opposite are a few examples of caricatures drawn with different media. In the first, the judge, the medium is oil pastel on a coloured background. We show this as an example of what you might like to try once your caricaturing skills have become more developed. Pastels can be a rather messy and difficult medium for the novice but, in expert hands, can be very impressive.

In the second example, the group of three heads, the medium is fibre-tip pen – cheap and excellent on all but coated papers, as the coating does not allow the ink to fully sink in and will cause it to smear.

The next is a typical example of a caricature produced for presentation or as a gift, containing elements (the apples, for instance) which have a special meaning for the subject. The medium is line and wash (waterproof India ink with a transparent watercolour wash).

The child with the football is drawn with charcoal; not one of the first materials you would consider for a caricature but one which can allow for interesting effects, such as smudging the line to produce shadows.

Finally, the full face caricature, for which wax crayon has been used. Again, this is not one of the more popular materials for caricature but one that might be fun to try when you are feeling a little more confident.

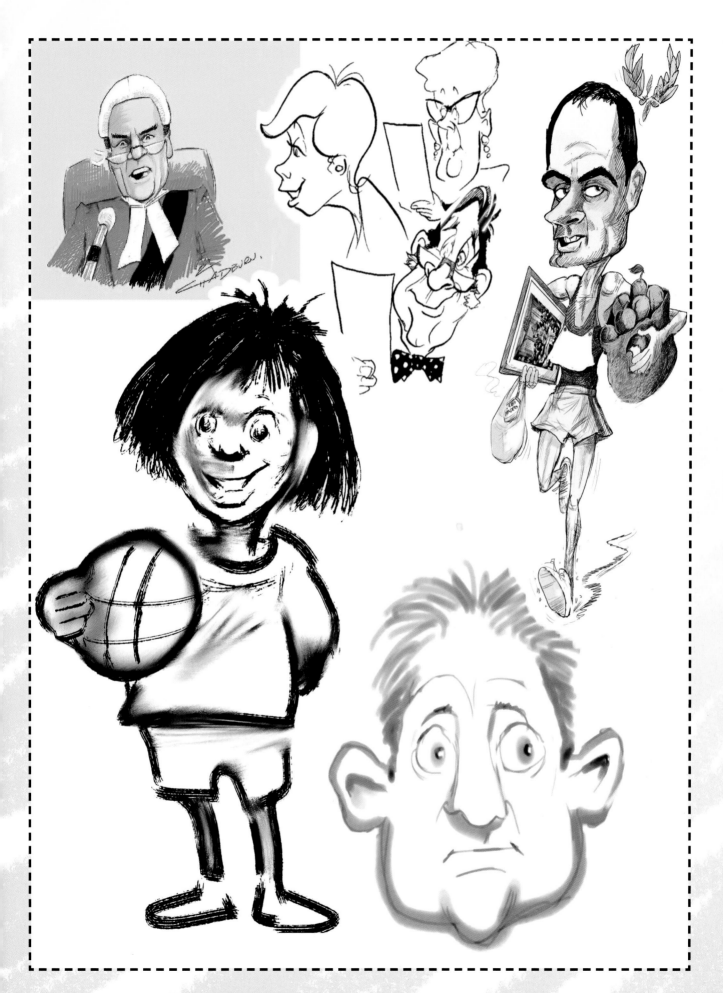

USING SOURCES OF REFERENCE

What sources?

Whilst it is true that if you know someone well enough it is possible to draw their caricature from memory, most of the time, when it comes to putting pen to paper, you will find that, no matter who your subject (or victim, as we sometimes like to call them!) is, you will need some form of reference material.

The ideal source of reference, of course, is the subject him or herself, sitting right there in front of you, but that is not always possible or practical. If your subject is a friend or relative, a live sitting might be fairly easy to arrange (although, if the caricature is intended as a surprise present, this clearly would not be a good idea!). And, if your subject is a celebrity, it is rather unlikely you could persuade them to drop in and sit for while as you draw them.

In cases where a live sitting is ruled out, an alternative source of reference will be needed, and the most common alternative is the photograph. Similarly, a video and the Internet are both good sources of reference.

There is one sort of reference that you should avoid at all costs, however, and that is what we call 'word of mouth'. More on that later.

These, then are the main sources of reference for caricature. Each has its advantages and disadvantages so let us examine each one in detail and explain their good and their bad points.

Using a live subject

The best thing about having your subject right there in front of you is that you control the situation. You can explain to your subject precisely how you want them to sit, what expression you would like, what angle they should turn their head, etc. It is important, though, to make sure that your subject is comfortable, because holding a pose for even five minutes is quite difficult – doubly so if the pose is an uncomfortable one. Any discomfort on the subject's part will reflect in their facial expression and posture, thus making your job very difficult. You should, in any case, try to capture a likeness as quickly as possible – taking no longer than fifteen minutes. If you find this impossible when you are just starting out, don't worry – just make sure you give your subject a decent break every ten minutes or so.

Another thing to be taken into consideration is the direction of the light falling upon your subject. A strong light, directly on the subject's face may be good for you but not for the subject. If he or she is forced to squint, this will not only give their face an unflattering look, it will also have the knock-on effect of changing other facial details. You can check this out for yourself, using a mirror.

Equally, you must avoid having light directly behind your subject because then you will, at best, lose a lot of facial detail and, at worst, find yourself trying to draw from a silhouette!

It is best, then, to have your subject sitting with a reasonable amount of light coming towards them at a three-quarter angle. This is not only the optimum angle for you and your subject, it is also the best angle to reveal those small facial details so important to the production of a good caricature.

There are other considerations to take into account if you are drawing outside, not the least of which is the weather! Wind can easily give your subject a bad-hair day and any extremes of temperature make it difficult for anyone to maintain a relaxed pose. Even noise can prove to be disconcerting.

If you must work outside, try to choose a gently shaded location away from direct sunlight. A table to work on would be useful, preferably with a large umbrella attached and a cold drink at your elbow if the weather is warm. If you are comfortable, then it's more likely that your subject will be equally relaxed, which will go a long way to ensuring a successful outcome.

One of the more difficult problems with a live sitter is to get them to relax – and if they are not relaxed, it will be very difficult for you to produce a good caricature. It's a problem, even if it is just you and your subject in the room, but if there are other people, friends, family or passing strangers around it can be quite a tough one. Your subject may be very self-conscious and sit there looking like a rabbit caught in car headlights, or, they may resort to nervous jocularity.

They may also, like many people, when asked to pose, whether for a caricature or a photograph, adopt a rigid posture and give you what we call the fried egg smile – eyes wide open with a big unnatural grin. In this latter case you should explain that it is not necessary for them to sit absolutely rigidly still.

At other times, your subject might want to eat, drink, smoke or chew gum as an aid to relaxation but you must politely insist that they refrain because any of these activities will distort the face.

The best way to get them to relax and to keep them relaxed is to chat to them as you draw. Be aware also, that as you are gazing into the face of your subject, so they, too, will be watching your face intently, looking for reassurance. So bear this in mind and try to maintain your best, friendly poker-face.

If there are others in the room, make sure they are positioned behind you and facing your subject. With this arrangement, any conversation with your subject will not cause them to keep turning their head. You should also discourage any onlookers from commenting on your uncompleted drawing! Remember, too, that your subject will constantly be tempted to catch a glimpse of the caricature-in-progress, so try to remove this temptation by not offering the opportunity.

Once you have completed the caricature you will encounter one of the biggest drawbacks of having a live subject: instant judgement! It is highly unlikely that, having sat there for what probably seems ten times as long as it actually was, your subject will allow you to hide the work away on the promise of showing or sending it to them later!

Don't be surprised if your subject doesn't initially consider your drawing to be a good likeness. People often fail to see themselves in their caricature the first time, in much the same way that they don't recognize their own voice in a recording. The best judges of how good a likeness your caricature is, are your subject's friends, colleagues and family. If they think you have caught the essence of your subject, then you can rest assured that you have.

Summing up

- Keep your subject happy and relaxed.
- Make sure the environment is a comfortable one.
- Remember your subject is also watching *you*!

Drawing from photographs

Working from a photograph does have certain advantages over drawing from life. For one thing, it removes much of the pressure you might feel. The worry of making mistakes and finding it difficult to capture the likeness in front of other people is removed and this, in itself, helps the learner caricaturist to relax and work comfortably. Although many professional caricaturists produce their best work under pressure, it is definitely not something we would recommend for someone just starting out!

If you want to draw a caricature from a photograph, then you should ideally take, or supervise the taking of, the photographs yourself. Note that we say photographs, in the plural, because it is always better to have a selection rather than a single shot. Faces can be very deceptive and a choice of angles, as shown here, will help you to visualize the three-dimensional face much more easily. This is important, even if you know your subject well. It is doubly important if you have been asked to caricature someone you do not know at all. So, if you can, get a shot from a three-quarter angle, one full face and one profile.

If you are unable to arrange for photographs to be taken specifically for the caricature and you have to rely on existing ones, try to get as good a selection as you can. If someone else is going to provide a photograph, make sure they understand your needs.

Of paramount importance is that the photograph be a good likeness because, despite the old adage, the camera can and does lie! We have all had a photograph taken, at some time or other, that doesn't seem to bear any resemblance to us – need we do more than mention, say, our passport photograph?!

Sometimes, the photograph you are given may be unclear or out of focus. The person giving you the photograph may not think this is important and, for them, it probably isn't because, as they know the subject, their brain automatically fills in the details the photograph doesn't reveal. For you, however, if you don't know the subject already, those missing details are a totally unknown factor.

Equally important is that it be a recent photograph. It is not unknown for a photograph to be provided, along with the information that, 'this photograph was taken eight years ago, before the subject lost his hair and had his ears re-shaped by plastic surgery. Oh, yes, he doesn't wear those dark glasses any more, either, or the beard!'.

Next, ask for a good-size photograph. Many a caricaturist has been given a photograph showing a group of two dozen people with a note attached along the lines of, 'that's him, the one just behind the lady in the big hat, back row seventh from the left'.

Finally, especially if you can only get one photograph, it must be taken from the angle at which you want to draw. As we have said, faces can be very deceptive and viewing them from the front, full-face, gives you no clue at all to how the face will look in profile or in three-quarter view. Similarly, a photograph in profile will not even hint at how the full-face looks. Ideally, if only one photograph is available, hope that it is a three-quarter angle one!

Working from video reference

From the point of view of seeing your subject in a natural situation, video is a good source of reference. If it is a video tape, the main problem is viewing it in a way that is comfortable to draw from.

The best form of video recording to work from is a DVD which can be run on a computer. This way you can take your time and select the best shots, freeze them and print them off so that you can work from them in the same way as you would a photograph.

Sourcing references from the Internet

The Internet is a wonderful reference source. If your subject is a celebrity, an image search on one of the many search engines will provide you with hundreds, if not thousands, of pictures. Even if your subject isn't in the public spotlight, it's surprising how many of us have our photographs on there somewhere! Don't forget, when searching for a good reference on the Internet, bear in mind what we have already said about photographs in general.

Summing up

• The more photographs you can have, the easier your job will be.
• Get photographs that are relevant to the way you want to draw your caricature.
• Above all, make sure your photographs are good enough, with sufficient detail for you to work from (see our examples at the end of this section, on page 27).

Word of mouth

The only reason we even mention this is because, at some time or other in your caricaturing life, someone will ask you to draw a friend or relative, even though they can't provide you with any reference material whatsoever. They will say something like, 'Oh, she's easy to draw, she's quite thin with blonde hair and a small nose.' They will often add completely useless information, such as, 'and she had her appendix removed last year'. Suffice for us to repeat, avoid at all costs or, at the very least, do your best to get them to obtain a photograph!

Last resort

Okay, so they can't supply you with any reference whatsoever, but they desperately want this caricature and they won't take 'no' for an answer. In this case, desperate measures are called for. Get as much information as you can about the subject's hobbies or interests, in particular any amusing incident involving these pursuits. Then draw a caricature in which the hobby (for instance, playing the euphonium) becomes the 'star' of the caricature. The subject can even have their back to the viewer – and if you at least know they are bald, or have a ponytail, so much the better. It's a cheat, yes, but it is a good work-around in that last resort.

The golden rule

Finally, if there is one golden rule with regard to a reference it is this: whatever source you use – live sitter, photograph or video – if the reference is not a good one, then your caricature won't be, either.

Here are some examples of good reference photographs. They are particularly good because of their size, clarity and the fact that they show excellent detail from both front and side views. In addition, both subjects have animated expressions and appear to be interested in what they are doing. The defensive mask that some self-conscious subjects hide behind is entirely absent here. That 'lived in' look comes across well in both faces, with the lines and creases, so helpful to the caricaturist, clearly defined – details which, in smaller, less sharp reference photographs, might not be as clearly visible.

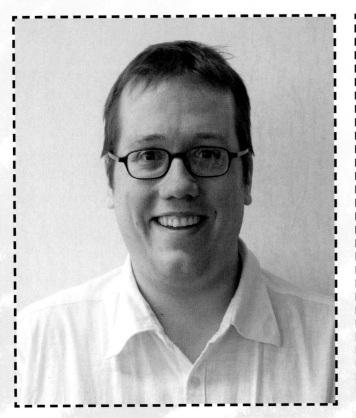

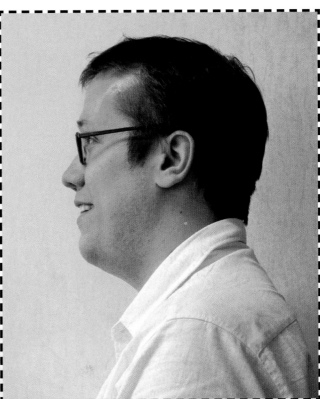

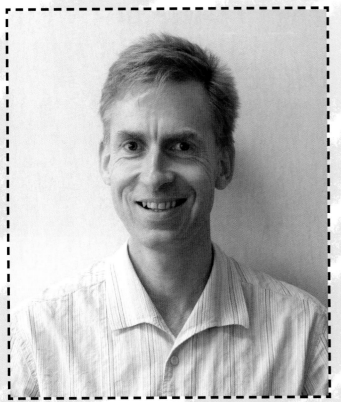

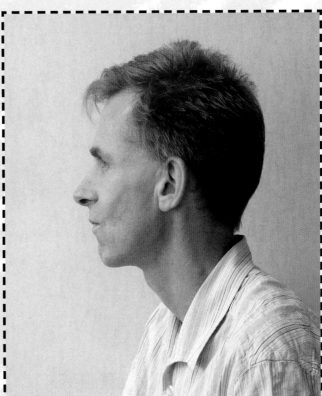

FACIAL BASICS

Although a caricature can encompass the whole of the body, the very heart of the caricature is the face – to such an extent that many caricatures comprise only the face. If the heart of the caricature is the face, then the heart of the face is the eyes, followed closely by the nose and mouth. These three facial basics are so important that, if you get them right, a recognizable likeness can be achieved without a single other line being added.

Let's look at each of these elements in detail. At this stage, simply take on board what we are saying and then, as you progress through the book, return to this section for help as you get down to some actual caricaturing.

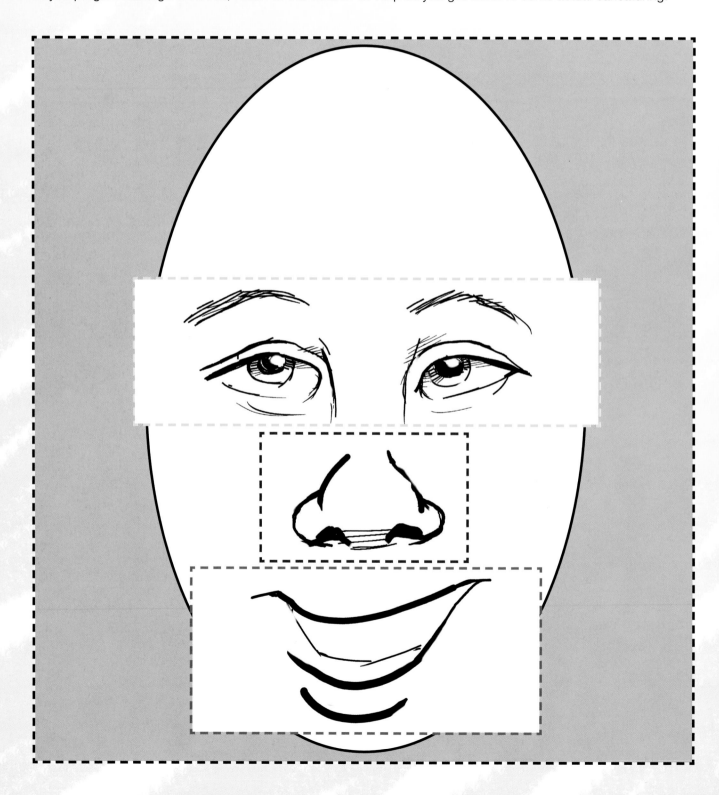

FACIAL BASICS

The eyes

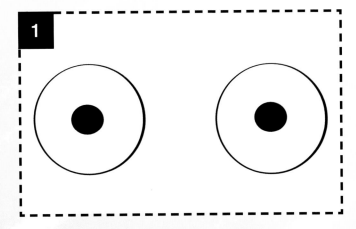

Mastering this skill to a reasonable degree is crucial to the success of a caricature and, for this reason, we recommend that you always start with the eyes.

To begin with, it is important to understand that when you look at someone's eyes, you are actually seeing two spheres which move, most of the time, in unison. Draw them differently, even slightly out of synch, and that look will be lost, along with the prospect of achieving a good likeness. In order to explain more clearly, let's reduce the eyes down to these very basic spherical shapes, as in **PIC 1**.

If you look at a series of photographs taken of an individual at various stages of their lives from childhood into adulthood, it's quite likely that the one constant will be that look in the eyes.

In any attempt to convey a likeness, getting the eyes of the subject to stare back at you from the paper is the most important – and rewarding – part of any portrait.

Moving on to **PIC 2**, notice how in the second pair, the pupils are very slightly out of synch, causing the eyes to look wrong. In the third and fourth pair, the pupils are still off centre but are now in synch – that is, moving together.

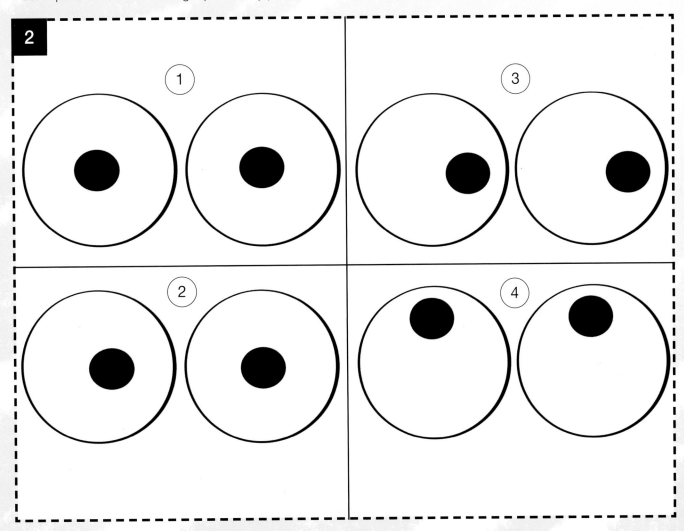

Now look at **PIC 3**, and you will see that we have added a little more detail. If you look extra carefully, you will also notice that the irises and pupils are not quite spherical. In other words they have been drawn in perspective. Add to this the radiating lines in the irises and the dot of light in the pupils and, even in this basic format, you can see that we are looking at the curved, mirror surface which the eye is. In this respect, the eyes are a unique feature of the face – an important fact that you should always keep in mind.

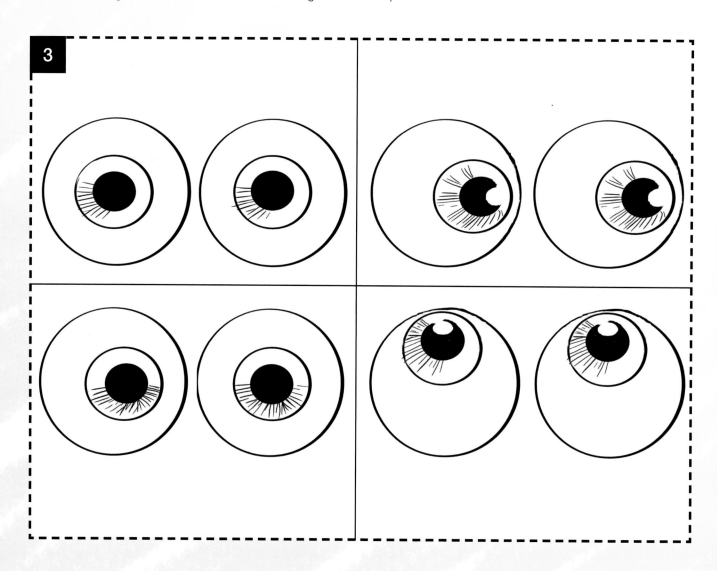

3

Having said that the eyes are spheres, in real life, of course, we can only see a portion of the sphere, with most of the front hemisphere obscured and protected by eyelids and eyelashes. So, let's put the eyes into this proper context. In **PICs 4, 5, 6, 7** and **8**, we have laid out the sequence of linework, starting with the upper eyelid through to completion. This is the sequence we recommend you follow whenever drawing the eyes.

Of course, nature provides an infinite variety of permutations and every pair of eyes will be different, not the least part of that variation being the nature of their setting. Age is a very important factor, so let's look at some examples. In **PICs 9, 10** and **11**, we show how the eyes develop as we get older. Notice the heavier line on the upper eyelid and the odd deeper line under and around the eye? Be careful not to overdo these, however, as you may fail to show the delicate nature of the eyes.

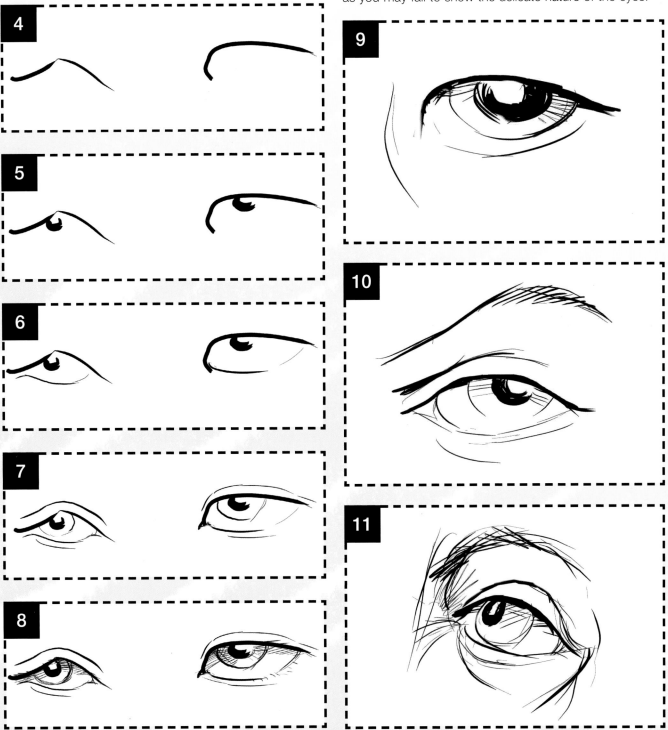

At the opposite end of development, in **PIC 12**, we have the eyes of a child. With children, the bone structure is far from fully developed and line work should be kept to a minimum. It might seem simplistic, but the easiest way to make a child look older than is the case, is too overdo the detail. And, since we are drawing a caricature and not a straight portrait, bear in mind it is traditional to over-emphasize the size of the eyes. The rule of thumb is: the larger the eyes, the younger the child.

12

Of course, a large number of your subjects will fall between these two extremes and as maturity into adulthood progresses and is reached, everything settles down into its place. **PIC 13** shows a typical example.

13

Some final thought before we move on. As you begin to draw the eyes, starting with the upper lid, pay attention to its prominence – does it cast a shadow over the eyeball, as in **PIC 14**?

14

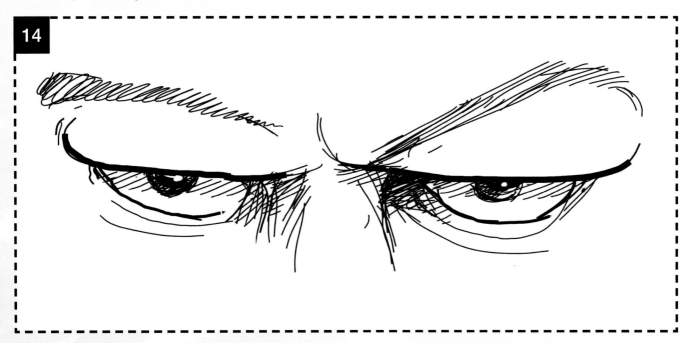

Also, examine carefully the area above, including the eyebrows and the space that separates them from the eyes. What about the shape of the eyebrows – are they distinctive enough to merit special attention as a major recognition feature? Getting these points right, bearing in mind our technique for the eyeball, is a big step towards executing a successful likeness.

With a more mature face, remember that the eyes themselves can remain young, reflecting an ongoing interest in life, even though the flesh around is ageing.

Sitters invariably worry about lines round the eyes, or crow's feet as they are sometimes called. The tendency of the beginner is to make them far too prominent. By all means show the odd deeper line, but keep a balance; subtlety is required which will come, mainly, through lots of practice.

One last note about age. Few things age a face more than the look of disappointment in having an unfulfilled life! Hopefully, you won't find eyes such as these in **PIC 15** staring back at you too often!

15

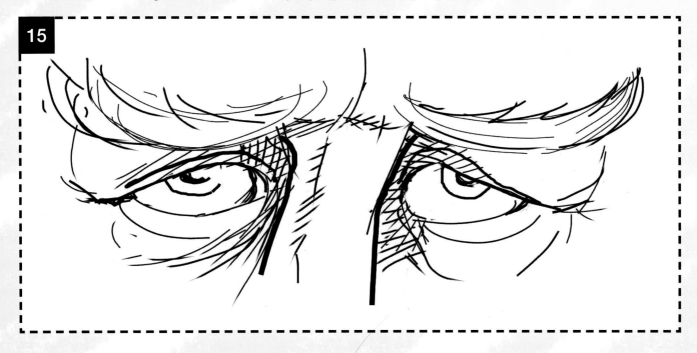

The nose

'Please don't draw my big nose!' Most caricaturists wish they had a pound for every time someone has said that to them. It is assumed by most subjects that the caricaturist will home straight in on their nose and exaggerate it to horrendous proportions. Of course, their fears might be justified! The nose sits at the centre of the face and usually points in the direction the owner is looking. Its relative shape and proportion is one of the first things you should consider. The key point is relative shape and proportion. If you overdo the nose, you run the risk of diminishing other key features that play an equally important role in the creation of a good likeness. Be guided by your first impression – useful advice for many other aspects of caricaturing, too.

In conjunction with the eyes, the nose forms the 'T', as shown in **PIC 16**, which is the basic foundation for any portrait. You'll find that we mention this eyes–nose 'T' a lot; it forms the bedrock of most portraits and is usually the part we suggest that you start from. We are aware of how daunting and intimidating starting with a blank sheet of paper can be, so adopting a system whereby you always know where to start will help your confidence enormously.

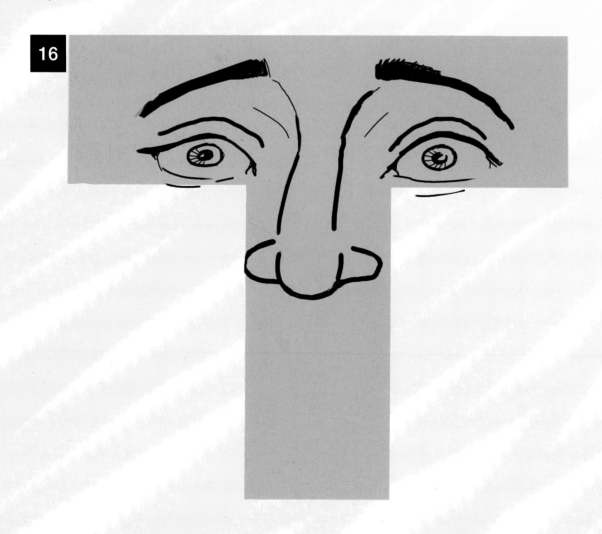

16

Now we know how mouths and eyes change shape but it is important to remember the fact that noses change shape too. If a sitter is apprehensive or excited, their nostrils may well be flared and a lot more noticeable than normal. When this happens, as in **PIC 17**, the caricaturist is in danger of falling into a classic trap – taking a feature that is not typical of the subject and exaggerating its prominence. This will, of course, make it a lot more difficult to achieve a natural likeness.

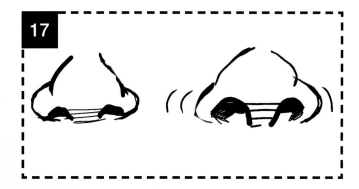

So, let's make a start drawing the nose. Noses come in all shapes and sizes, from the ski slope to the stubby. **PIC 18** shows a small selection of an almost infinite variety of the shapes you will encounter.

Try not to feel intimidated by size (or lack of) where the nose is concerned, though there is no denying its importance to the picture. It is traditional, with some caricaturists, to greatly exaggerate the nose as part of

their individual style; this approach may be something you feel might suit you – if so have a go, but be aware that in so doing you can easily diminish other features that may be equally important as feature waypoints.

Practise drawing a page of noses, see if you can come across any shapes which we haven't included. Also, try to keep your linework to a minimum and avoid getting bogged down in detail.

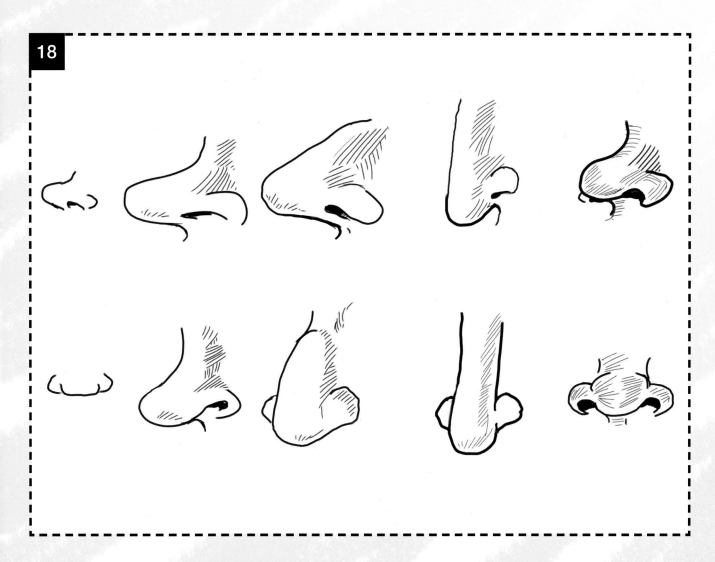

Whatever the shape of your subject's nose, however, you may well find that there are very few lines on which to hang your pen. Quite often the angle from which you choose to draw the whole portrait will be determined by the angle, size and shape of the nose itself. The three-quarter view, demonstrated in **PIC 19**, is a favourite with many caricaturists – that is, the angle halfway between full face and profile.

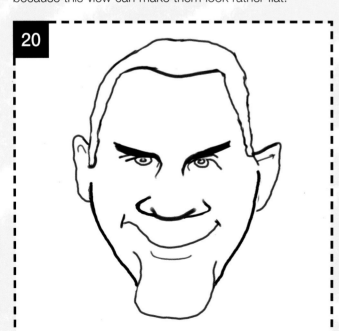

19

The reason for its popularity is you get a good overall shape from hairline to neck. Why is this the preferred angle? If you look at **PIC 20**, you will observe that whilst the full face offers good definition for eyes and mouth, it is not so good for the nose, chin and overall shape because this view can make them look rather flat.

20

Profile caricatures, incidentally, are not the norm, but there are certainly times when this angle would be your best option. We shall return to drawing profile caricatures later in the book (see pages 80–83).

So, here we go, then. Having commenced drawing your caricature with the eyes, knowing where to start drawing the nose is not a problem because the gap between the eyes is the ideal place to start the nose. Look at the prominence – or lack of prominence – of this area, as shown in **PIC 21**. The bridge of the nose may extend up to the forehead or, on the other hand, not really become obvious until it gets below the eye.

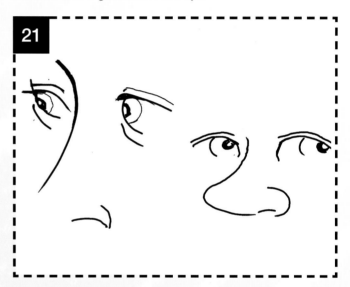

21

Draw the outline first, as in **PIC 22a** moving down the face. This is where you make a value judgement on the size and prominence of the nose. Be guided by your overall impression of the face. Don't be afraid to erase it and start again – this is an absolutely key line upon which the success of the portrait could well rest.

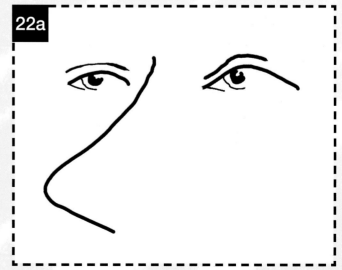

22a

Next draw the nostrils, **PIC 22b**, and then the rounded area on the outside of the nostrils, **PIC 22c**. You will notice that we have used small shading lines to help define the shape. It is surprising what a difference just adding the outline of the nostril can make. Incidentally, when, as here, we are focussing on one detail of the face, it is easy to adopt a blinkered style of vision. Remember to take a step back from time to time, as you are working, so that you retain an overall impression of the way your drawing is coming together.

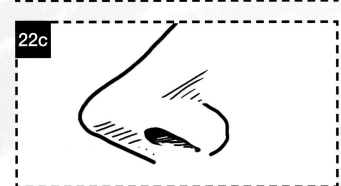

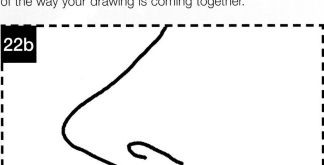

Now look at **PIC 23**. As we said, when drawing full face, the nose lacks hard lines to use as a basis from which to work. So, begin where the nose meets the eyes to first draw these shadow/shape lines – this is usually the area of the face where there is the deeper shadow – then carefully work downwards, as in **PIC 24**.

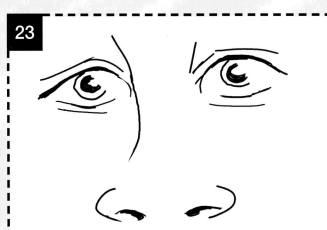

Notice how the shadow lines on the left side of the nose suggest the shape of the nose. The basic facial features are really starting to take shape now.

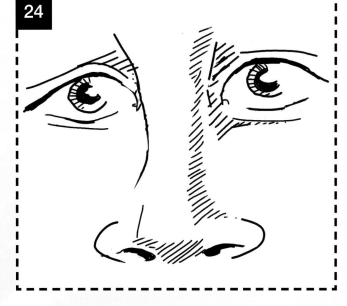

A useful tip to keep in mind if you are drawing full face, as shown in **PIC 25**, and if the nose is quite prominent, is to use a thicker line for the base, This will give an impression of underlying shadow and help emphasize the nose's prominence without exaggerating its size.

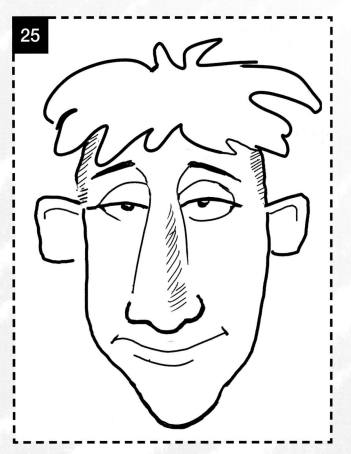

The mouth

Drawing the mouth can be quite daunting when you consider the rapidity and frequency with which its expression changes – as, for instance, in **PICs 26 a**, **b** and **c** – even when the rest of the face is relatively still. This isn't likely to be a problem, of course, if you are working from a photographic reference but with a live subject it is definitely an important factor (and a sitter's attempt at holding onto a pleasant smile can so easily turn it rapidly into a pained grimace!).

You may find that the lesser of two evils is to encourage the sitter to talk to you as you work. Whilst this turns the mouth into a moving target, it may well give you a more relaxed overall shape, with the added bonus that the sitter may become so interested in what they are saying, they completely forget what you are doing! Equally useful, in conversation it is not uncommon for a subject to let information slip that could be useful to your interpretation of their face!

With a relaxed, talking subject you will eventually have to decide on what shape you are going to give the mouth. As you are producing a portrait that will be viewed and judged by their peers and family, go for the most common shape that they adopt during your conversation. Getting the mouth shape right but in an untypical pose will lessen the impact of your work.

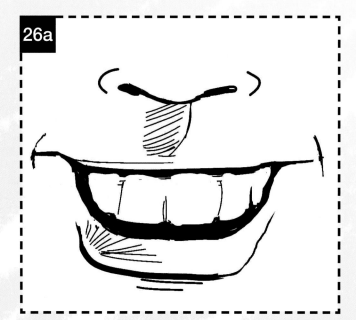

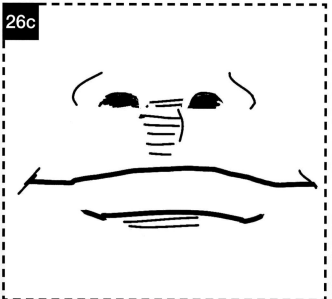

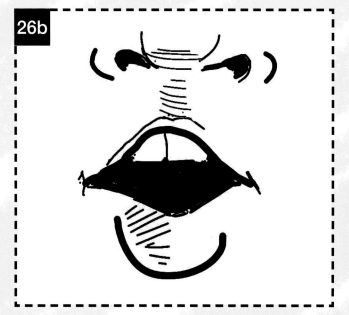

Laughter (26a), surprise (26b) and contentment (26c) have all been captured here. Notice how the different expressions of the mouth also affect the shape of the nose.

So, apart from the fact that the mouth would naturally seem the next place to draw after the eyes and the nose, there is a very practical reason to do so, inasmuch as getting this part of the caricature out of the way will take some of the pressure off both your subject and yourself.

So where do you start with the mouth? First, let's break it down into three parts: upper lip, teeth and lower lip, as in **PIC 27a**.

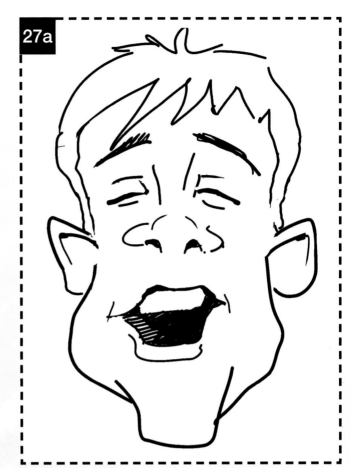

If your subject isn't showing their teeth, you can immediately reduce this to two parts as in **PIC 27b** and, if they close their lips, you can get away with a single line, as in **PIC 27c**. So you see, the mouth may not be such a daunting prospect as at first it seemed!

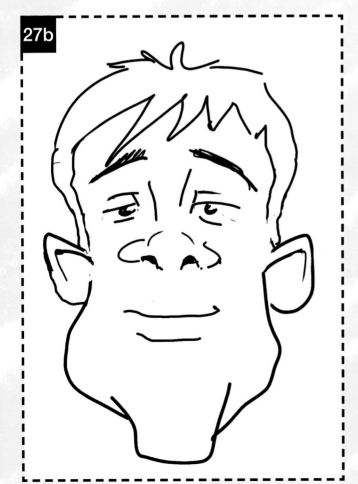

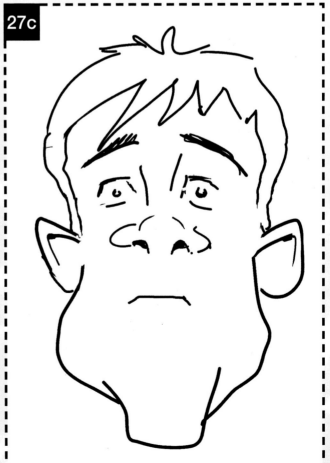

However, in reality, most caricature portraits (with the exception, probably, of political caricatures) will show the subject with a happy expression. In fact, with live caricature, it is standard practice to encourage the sitter to smile. Try to make your model as relaxed as possible. So, back to our three elements.

Beginning with the top lip, then, use it as your base line and draw it in three parts – the bulk of the line will curve round the teeth but the edges can follow a different path, as demonstrated in **PICs 28a** and **28b**. This is most noticeable with a wider mouth or, in particular, when the subject smiles broadly.

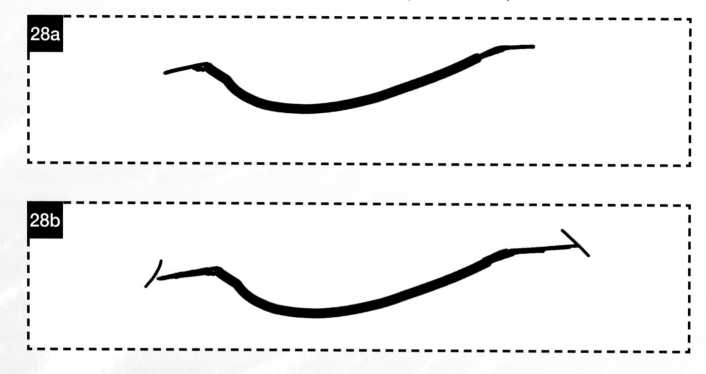

Having drawn the top lip as your base line, quickly capture the prominence and shape of the teeth (but don't concern yourself with detail at this stage) and then the bottom lip. **PIC 29** shows how your drawing of the mouth might be looking at this point.

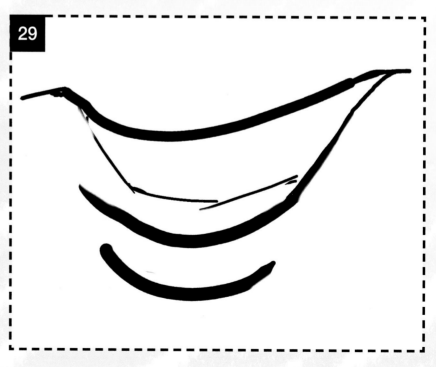

Now, of course, you are not drawing the mouth in isolation and it is important to bear in mind its position relative to the nose (this is where your impression of the face is so important). Moving the mouth up, as in **PIC 30**, or down, as in **PIC 31**, you can emphasize the size of the nose or diminish the chin – a very useful technique to keep in mind.

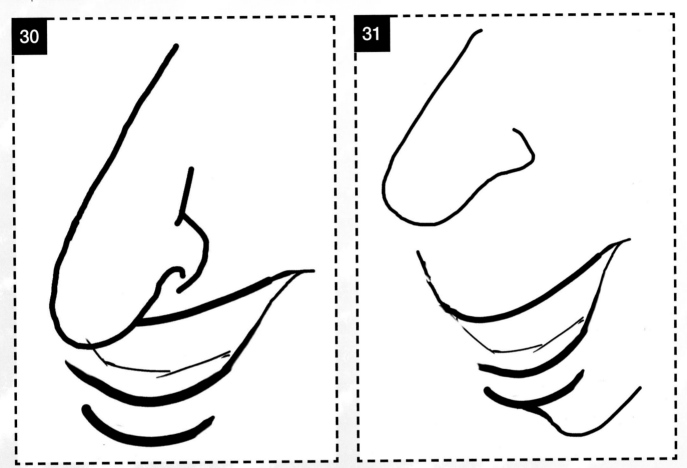

At various times in this book, we mention how the weight of a line can lift and give prominence to various features. This applies particularly to both noses and lips, the reason being that both these features can generate a good deal of shade. This should be regarded as an opportunity.

In the world of comic strip and the graphic novel, facial features are regularly illustrated, not by drawing a line round something but by simply drawing the shade that such a feature may project. You might find it helpful to take a close look at this form of drawing since it is a kind of fictional caricature. There is absolutely no reason why this technique cannot be applied to the caricature of real faces. As a separate exercise why not try to produce facial detail simply by using shadow alone – remember, every time you pick up a pen or pencil try to learn something new.

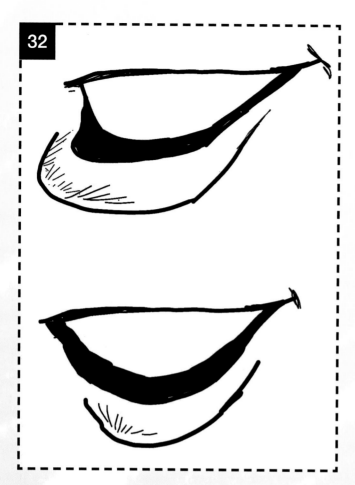

The bottom lip can be drawn using two similar lines, one showing the inner lip, and the other the outer lip, as in **PIC 32**. You will notice that a few lines of shade have been added to these illustrations. This really helps to lift the lips away from the background. Adding these simple lines also acts as a natural breather and, as you apply them, following the shape of the lips, you can at the same time work out what you are going to do with the chin. This sort of pacing, whereby you take a tiny break from doing something more complex, is a very useful little trick.

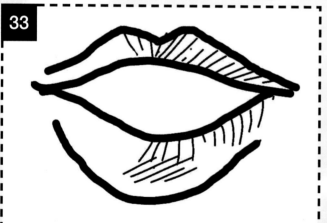

Note its relative size and exaggerate it if you consider it to be an important recognition point. Generally speaking, when drawing adult males, you wouldn't repeat this exercise with the top lip because its prominence tends to decrease as the face matures and fills out. On the other hand, many females retain a full top lip, as in **PIC 33** and, indeed, emphasize it with makeup.

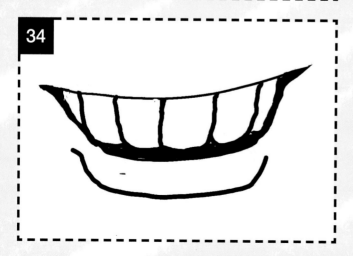

So, what about those teeth? You need to add a little detail, but beware! A common mistake when drawing teeth is to draw lines around each individual tooth. This creates an effect not unlike a cell window, as you can see in **PIC 34**.

While teeth may indeed be a noticeable feature of your subject, you must consider carefully how much prominence to give them in this way, so as not to diminish other features and leave you with an unbalanced portrait. Balance will be achieved providing you have correctly identified the recognition points of the face and drawn them in relative size and prominence. It may take some time to master but remember that every time you pick up a pen or pencil you will learn something new.

So, with **PIC 35** and a few final words on the mouth, we have completed our quick tour of the three basic elements of the face and you have seen how they are brought together to provide the basic foundation of your caricature. It's time then to put all of this into practice and get involved with drawing some actual caricatures. Don't let this prospect daunt you. You will make mistakes and you will learn a great deal from them, just as we all did and just as we all still do!

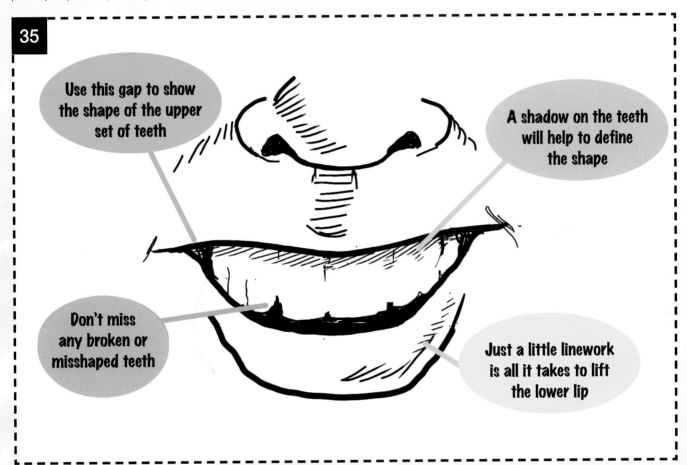

35

Use this gap to show the shape of the upper set of teeth

A shadow on the teeth will help to define the shape

Don't miss any broken or misshaped teeth

Just a little linework is all it takes to lift the lower lip

The next section of this book comprises practical workshops devised by Steve Chadburn. As a specialist caricaturist, Steve is an expert in all aspects of drawing caricatures, from the hectic world of live corporate events where each caricature must be completed, without any preparation, in under five minutes, through to the more leisurely but no less demanding art of the studio caricature, in which a piece of artwork may require a whole day – longer if the caricature is of a large group of people.

In each of the workshops, Steve guides you, step by step, through the creation of a caricature, working from the photographs that accompany his drawing. Steve has selected a variety of subjects, each of which demonstrates different aspects of caricature. Clearly,

it would be impossible to cover every single variation in the human face, but these examples, with their variations of sex, age and racial characteristics will allow you to explore at least a few of the main areas of diversity.

We suggest that as you work through this part of the book, you follow Steve's steps and draw the caricatures yourself, step by step. It is important to realize that no two caricaturists will produce the same drawing, even though they are working from the same photographs, so, use Steve's drawings as a guide but try not to simply copy. Look at the photograph, see how Steve has interpreted the features, but then try to do it your own way.

All set? Then let's begin!

STEP-BY-STEP PROJECTS

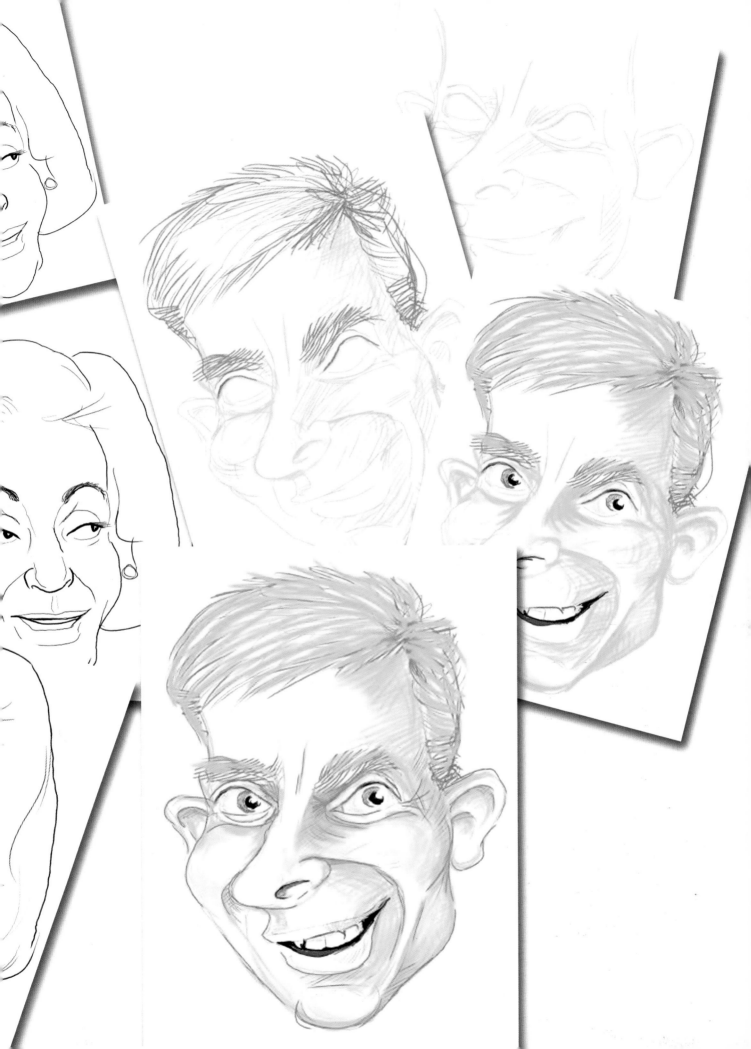

A HAPPY-GO-LUCKY LADY

With caricature, first impressions really count for a lot – and never more so than in the case of our first subject. Here we have a young woman, clearly full of life, projecting a positive fun-loving personality. No matter how perfectly one could draw her picture, no matter how line-perfect, if it doesn't effectively convey her bubbly personality, it will only have done half the job.

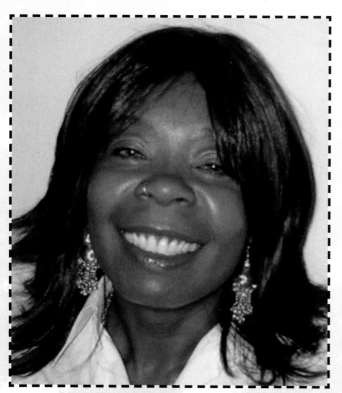

So, which features immediately stand out? What are your first impressions? Look closely at her face. Where are the key lines on which to build the portrait? For me they are the eyelash line, the base of the nose, and the distance from the nose to the top lip. This is a good place to start and those lines will provide a good foundation on which to build the picture. Here are a couple more pictures of our subject, a three-quarter view and a full-body shot, to help us get a really good idea of her personality.

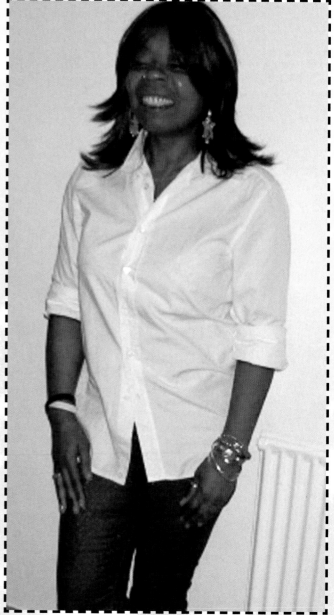

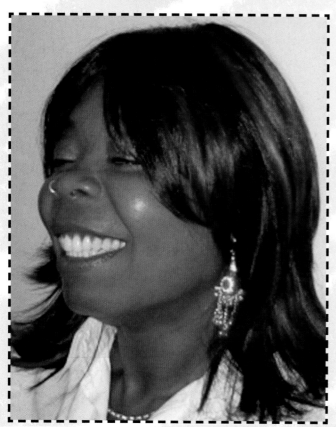

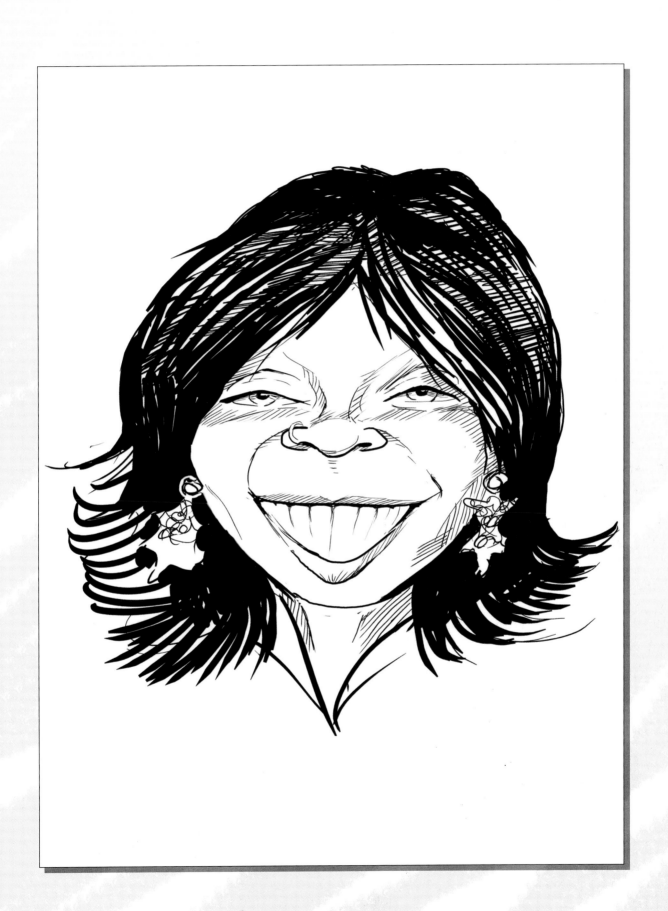

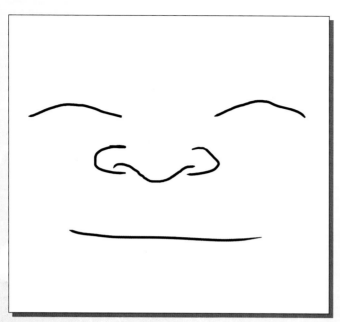

Step 1

Think about where you will start. This would normally be the eyelid line, but you might want to start with her distinctive nose shape and work outwards. Eyelid, nose and top lip – the framework you will need from which to progress.

Take your time with this; be prepared to redraw it several times. This is the most difficult part of a portrait, where the subject isn't yet staring back at you, and there seems to be a lot of blank spaces to fill. You may be tempted to rush in and fill those spaces as quickly as possible but these intitial, very simple lines are going to form the very foundation of your caricature and are, therefore, worth spending more time and effort on than might at first seem necessary.

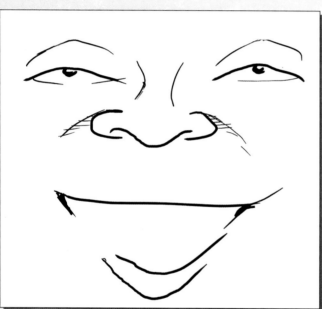

Step 2

Now we are definitely making progress. The key factors here are the depth of the eyelid and the shape of the mouth. As the upper nose doesn't project very far, I keep the lines there very light with the intention of using them as guides later. It is a good idea to put the irises in now – for one thing, doing this at this stage establishes the position and spacing of the eyes, whilst still leaving plenty of options for how you finish them later. Mostly though, the drawing of the eyes turns a series of bumps and hollows into the beginning of a real face.

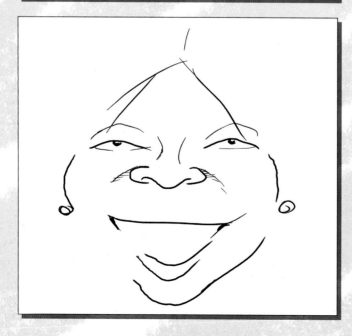

Step 3

Having established some of the basic inner-facial geography, we need to pull back and begin considering the overall shape of the face. As a general rule of thumb, when drawing any female, I recede the chin slightly. If the chin is too prominent, your caricature can acquire a degree of masculinity which will be very difficult to redress. Also, a more subtle chin will, in the case of this subject, promote her prominent mouth and bottom lip without having to draw them in a grotesquely oversized way.

Step 4

The subject is now beginning to stare back at you. Drawing the earrings at different angles does a lot to convey movement and the vitality of the subject. Be careful with jewellery, though – when you draw the nose-ring, make sure that it cannot be mistaken for anything else! Professional caricaturists will give prominence to various lines by adding weight (making them slightly thicker). They'll do that instinctively but you will need to think it through at first. Here I have given weight to the line of the eyelid, to indicate the eyelashes whilst at the same time not overemphasizing them, finishing the shape of the eyes using a lighter line.

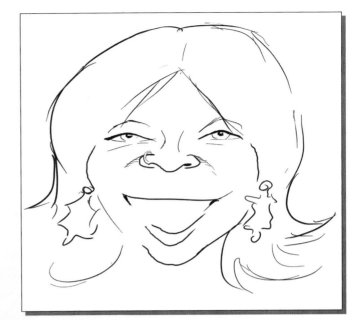

Step 5

At this point we must try to lift the drawing from a flat, two-dimensional image, to a portrait that stands out and demands attention. Very carefully begin to add shading, balancing it with increasing the thickness of key lines. I usually start to shade in the areas where the darker tones are to be found, around the nose, lips, and where shade from the hair falls on the face. This form of shading, using lightly drawn lines, is called hatching. It is a very effective way to indicate shadow and form but you must be really careful not to overdo it. Practice, and learning the knack of knowing when to stop, are the key to good shading (if your caricature looks as though your subject has a couple of black eyes, you know you have gone too far!).

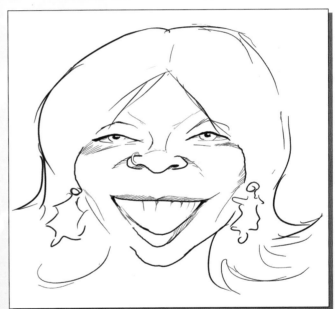

Step 6

Into the finishing stretch now. Our subject has streaks in her hair, so convey these by variations of tone. I have picked up the cheekbones using shade from the hairstyle. Remember not to overdo the shading – allow light to help bring the face to life. It is also most important not to use heavy shading to denote skin colour. Teeth, too, must be handled with a lot of care. Avoid using the sort of heavy lines which will give the impression of prison bars which will not only look unattractive but will overshadow everything else. And remember that both the upper lip and eyelids will drop shadows that you can use to emphasize shape and form. It is in this final stage that you can drop in those little extra details such as lightly indicating the filigree of the earrings and the neckline of the subject's clothing.

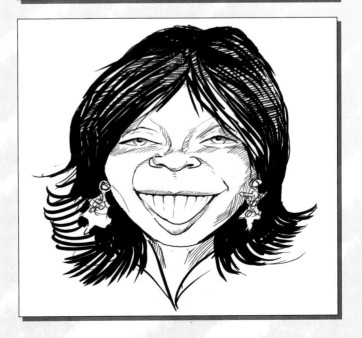

A FACE THAT'S BEEN AROUND!

Here is an interesting, lived-in face – and at first glance, one that you might think of as an easy subject to draw. Bald head, beard, a few lines to hang your pen on. Simple? Starting off with this impression, however, would be a mistake. My first impression is of someone with a pale skin and a fair complexion. Working in black and white requires some skill if such subtleties of tone are to be conveyed, so you must keep your line work fine, with a light touch, with a subject such as this one.

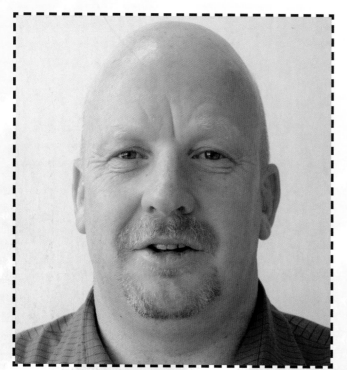

As we have said, when working from photographs, it is important to get the best references possible. Sometimes, however, you will have to make do with what you have got. Looking at the first two photographs, I felt that the only thing missing was a card with a row of numbers! – like a police mug-shot, they are a little square. So I made the decision to draw this caricature from the three-quarter angle. It can, indeed, be an interesting, not to mention, challenging, exercise to produce a portrait from an angle you haven't actually got in front of you.

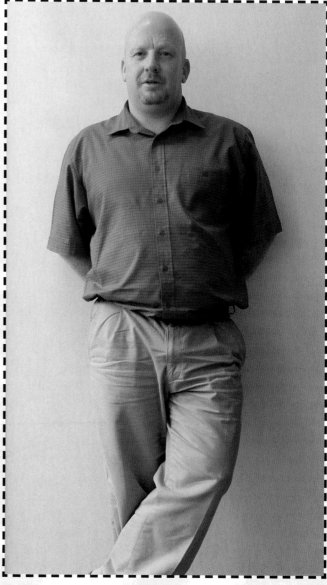

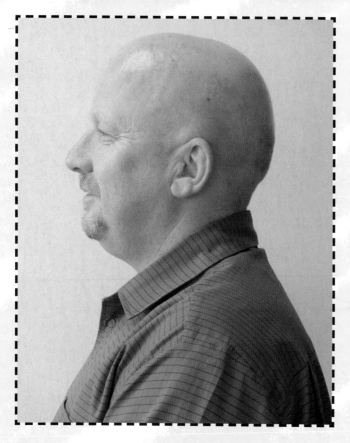

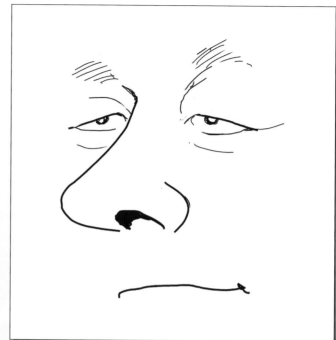

Step 1

Let's start. Remember what we said earlier, in Facial Basics about the T area see (page 34) formed by the eyes and the nose? We'll begin there. You will note that there is a prominent fleshy area above the eyes, so the line that delineates the shape of the eye will be crucial. The nose will play an important part in the picture, too, and I wanted to place the position of the upper lip prior to including any facial hair.

Step 2

Here is probably the trickiest part of this portrait: the portion above the eye but below the eyebrow, which is quite rounded here – something that you must attempt to convey. Put the irises in as a guide, and follow our advice on drawing eyes (see pages 29–33), then carefully indicate the eyebrows. At this stage it's an act of faith, but you must get these foundations right in order to progress.

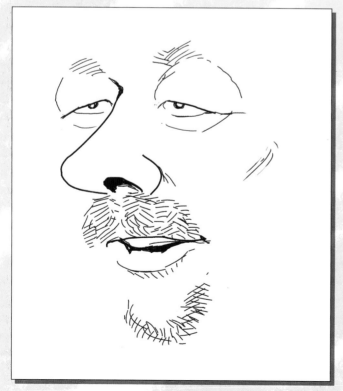

Step 3

I wanted to introduce the facial hair and shape of the mouth next. The fairness of the features means that any overdrawing of the beard will spoil the portrait. You are seeking a tonal value similar to the photographs, so look at how the beard lies and mimic it, being careful to avoid too many lines. Try also to follow the shape of the face if you can.

The bottom lip is fairly noticeable so now is the time to put it in place. The facial hair, directly below the lip is very useful for adding emphasis. You may have noticed that I have also sketched in a few quick lines of hatching on the left of the face which helps to define it and suggest shape before I actually draw the outline. It is worth pointing out here that you are still working on trust (or hope!) – the parts you have completed don't yet stare back at you in a recognizable way. All caricatures go through this phase, and the key is not to panic and rush into altering what you've done.

Step 4

Now I have added the outline, and the subject starts to look back at you. I have made the head slightly pointed – an instinctive thing to do, and I just felt it would look right. It is my style not to overdraw the head since it could detract from important detail elsewhere. This is just my opinion, however, so try it differently by all means. Your personal style is not just about how you draw but also how you think.

Because I wanted to make a feature of the ears I've added a glimpse of the right ear in the drawing, although strictly speaking, from this angle, it wouldn't show at all.

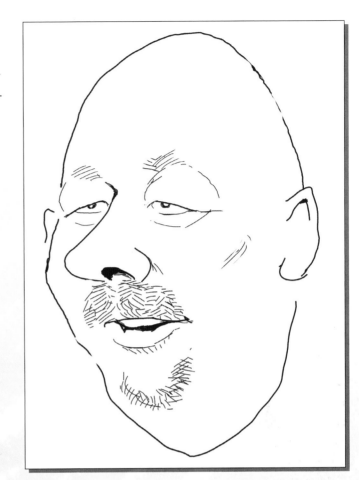

Step 5

Now we come to the best part! All the basic detail is in place, so before finishing off, let's pause, step back, and look at the photographs again. Of the three pictures I have worked from, the one I used the most was, perhaps surprisingly, the full-length one. The other two had good close-up detail, but you need to look at the overall picture to remind yourself it is an individual you are drawing and not a mask.

In this final stage, we need to add a little emphasis to some particular points. First, shadows at the bridge of the nose. When you add shadow to a face it is best to start in the gap between the nose and the eyes (there is always shadow here) but again, try not to overdo it. Note that the upper eye also casts a shadow on the eyeballs. Next, finish off the eyes, referring to the eyes section in Facial Basics (see pages 29–33) if you find that helps. In this caricature, I have only put the lines around the eyes that I felt relevant – this is a face that smiles a lot, so I wanted to make that point without spoiling it, which too many lines might do. The final caricature should reflect what I said at the beginning of this session – that with a pale complexion and light hair, you need a lighter touch.

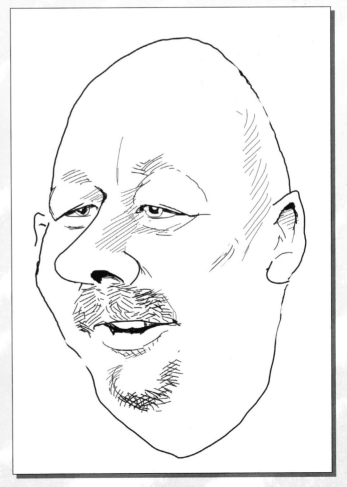

A LADY WHO ENJOYS LIFE

In this session we draw a lively and interesting face, helped by the fact that our subject is interested in posing for the photographs. Needless to say, a lively and interesting face deserves a lively and interesting portrait, and, as we said before, the quality of the reference is paramount to a successful conclusion.

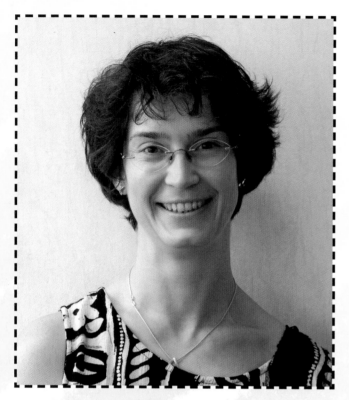

This time I am using a different approach – I am going to add a little colour. Don't be daunted by this. When I say a little colour I mean just that – I'm not going to burden you with a master class in the subtle skills of fine art portraiture. All of those skills could equally apply to a caricature, of course, but the economical use of two or three colours could add a new perspective to your finished work and boost your confidence, too.

You could still use a pen and black ink for the line work, but I've always found that black ink can be a little overpowering in this context. Also it is not unknown for so-called waterproof ink to smear when having watercolour added on top. Instead of pen and ink, then, I shall be using a 2B pencil. Remember, too, that you should also use a paper that will stand up to the rigours of a degree of soaking, such as a smooth cartridge paper. It is probably not a good idea, at this stage, to use watercolour paper, because the heavier texture will unduly affect your line work. Later, as your skill develops, you may well want to try using watercolour paper, specifically because of the way it affects your line work.

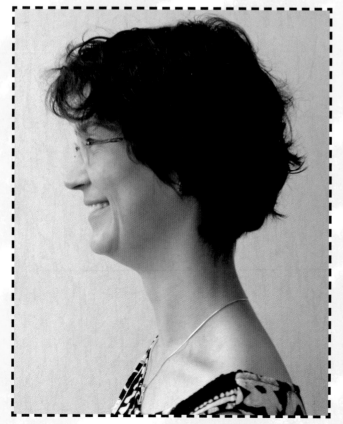

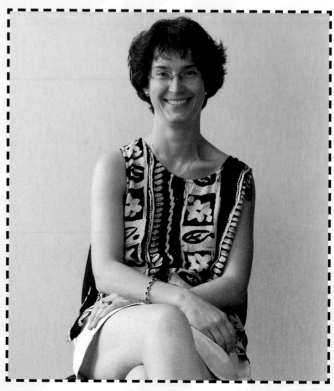

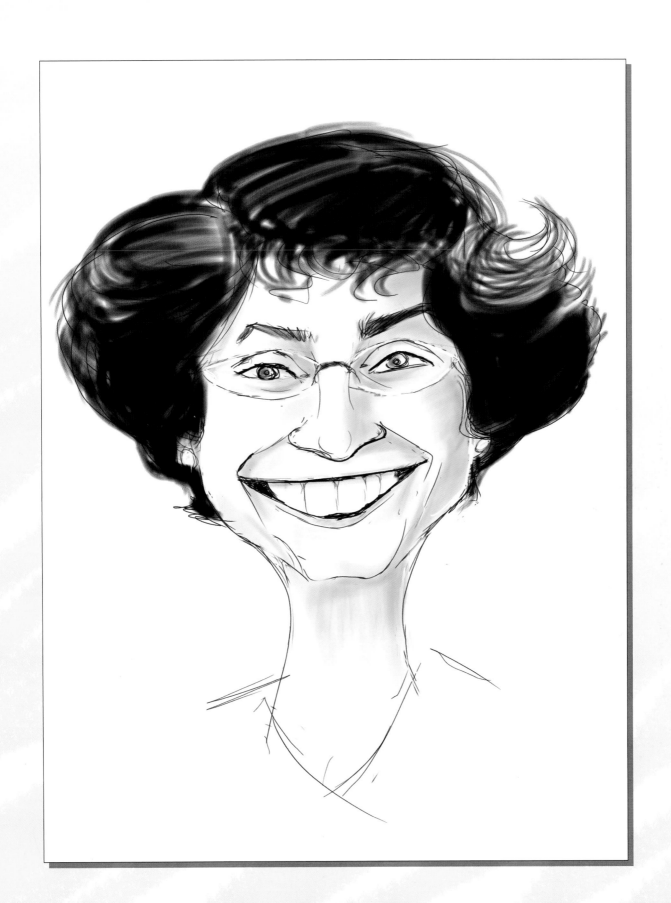

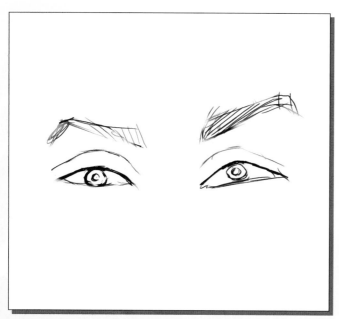

Step 1

Because we plan to add colour, it isn't necessary to draw shadow – the colour will do that for you. Remember that you now have two media, each with differing properties, so try to think of what positive aspects each can bring. The pencil allows you to gently sketch detail on the eyebrows and eyes, knowing that all it will take is a touch of colour to lift and finish them.

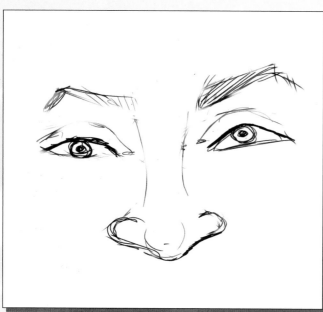

Step 2

To complete our classic T, we draw in the nose. I have focused on the basic shape of the base, drawing attention to it as an important feature. You might find, when using a pencil, that the application of the line work becomes a little looser and broader. Don't worry; I find it looks fine providing you don't overdo it. If you do, there is always the danger of damaging the paper when you try to erase the excess.

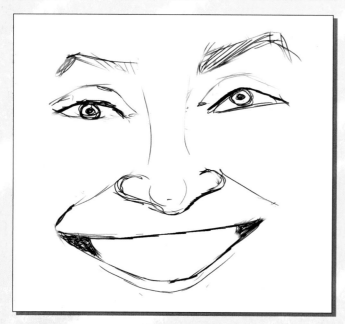

Step 3

Position the outline of the mouth, bearing in mind that you can always add further detail after you have added colour. Read over the section on Facial Basics (see pages 38–43) if that helps – this is something that I would encourage you to remember whenever you are a little unsure of what you should be doing. Think of that section as a safety net. In this instance, everything you need to know to understand the way I have drawn the mouth is covered there. In this caricature, I have chosen to make the mouth a major feature – a personal choice, because different caricaturists see their subjects in different ways. Was mine a good choice? What do you think?

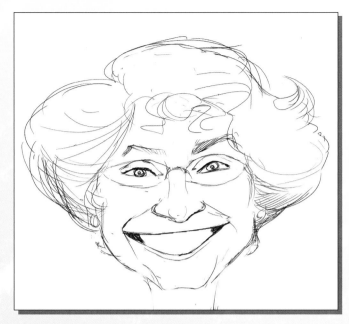

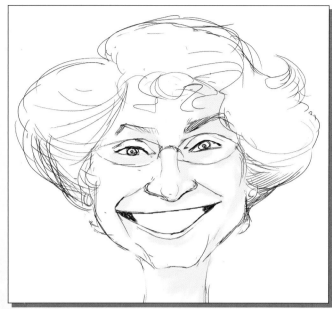

Step 4

In the next stage of the drawing, I have exaggerated the hair and neck a little – remember that caricature is not just about facial features. Now, this is the first exercise we've done with the subject wearing spectacles. At this point, I always ask myself this question: does the individual wear the spectacles or do the spectacles wear the individual? Experience is really the guide here, but it comes down to how noticeable the glasses are. In this case, the specs aid interpretation and don't mask key lines around the eyes and brow. Some people do hide behind their glasses and it's your job to find the real person underneath.

Step 5

As I begin to apply some simple colour – you should use a good quality sable brush which retains a good point when wet – things take an interesting turn. With Caucasian faces I start with a pale, cool red. A cool red is similar to crimson which leans towards a blue hue as opposed to a warm red which has more yellow. I find that, quite often, all you need is a combination of these two contrasting warm and cool reds, applied in the palest of tints, as you carefully build up the depth of colour. You have to work your way into a face, starting with those areas that have shade – the area between the eyes and the bridge of the nose, the creases in the smile and under the chin. This lady has pale features so the cooler red is dominant.

Step 6

Again, keeping it simple, I use one colour for the hair, following the shape and going easy on the eyebrows. Photographs are usually unreliable with showing true colours, so here I've decided on a paler version of the hair colour. You may think my hair colour looks rather heavy for watercolour, and this is intentional. Remember that we are drawing a caricature, not a delicate watercolour, and we can afford to be bold and use a thicker consistency of paint than a traditional watercolourist would.

Next I've added a pale blue to give me shade on the teeth and eyeballs – and I have also I've put a little on the lenses to lift the spectacles away from the face. Finally, I have added weight to a few lines with the pencil, including the teeth, which needed just the lightest of touches.

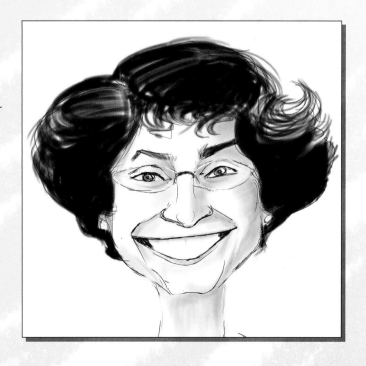

SMOOTH CHARACTER

Here we have a young man who, at first glance, you might think would be difficult to caricature. Young people's faces can lack the wear and tear which, in older subjects, gives the caricaturist something to get to grips with, and on which to base the line work. However, with a little more scrutiny, you begin to see those recognition features like waypoints waiting for your pen. The cleft chin for instance.

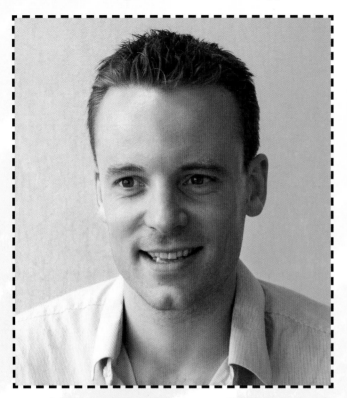

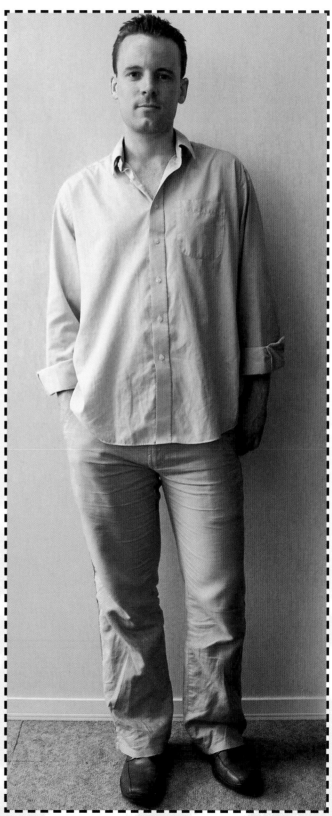

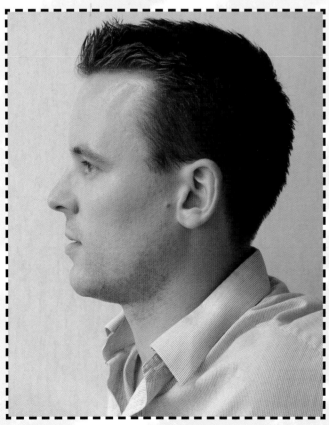

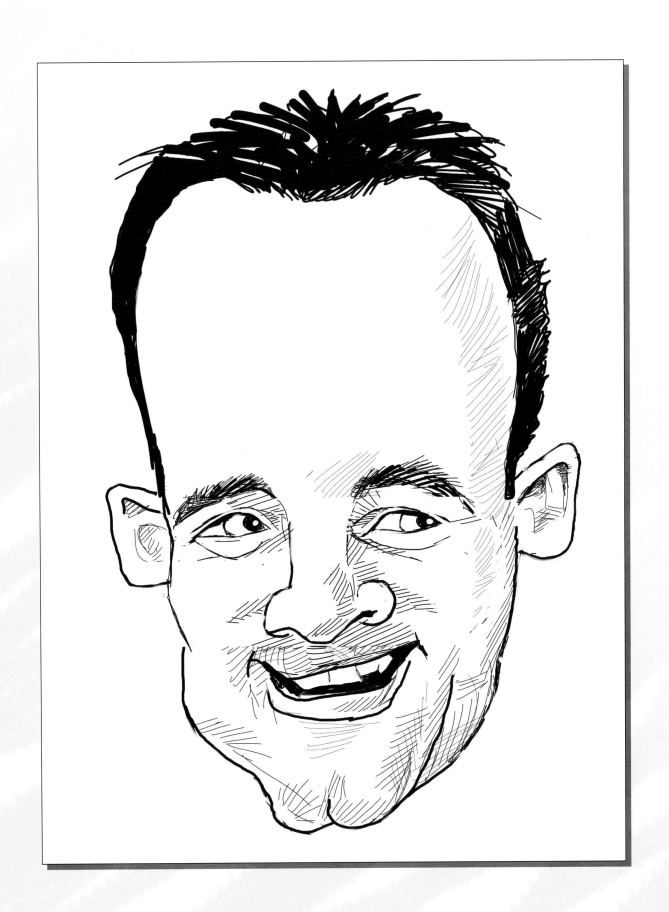

Step 1

Starting with the eyes, note that they are slightly hooded, and project a confident stare. For this reason, I have broken my own rule about having the subject looking directly towards me. Doing it this way, implies that, maybe, there is something of interest just off the page, whilst, at the same time avoiding giving the impression of what could be – with the lop-sided grin and seemingly flared nostrils – a younger version of Jack Nicholson in The Shining. Flaring the nostril helps towards developing the particular effect I am aiming for with this subject – the sort of tough guy look that many young men like to cultivate. Twisting an image, first from realism to caricature, and then to a particular personality type takes confidence and lots of practice. As an exercise, you might try transforming a relative into a stereotypical type of character (villain, celebrity, superhero, for instance) maybe to use on a humorous birthday card.

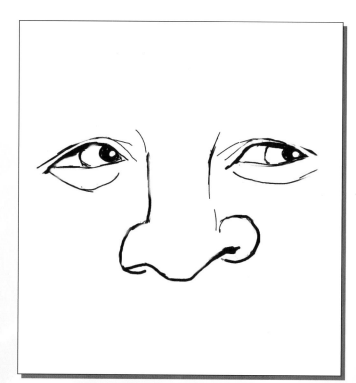

Step 2

The eyebrows are prominent and help to give you a baseline for the forehead and placement of the ears. Normally, the eyebrows get bushier and more noticeable with age, so when, as a caricaturist with your attention for detail well-honed, you are confronted with a younger face possessing such a well-developed feature, you know immediately that it will play an important part in the picture.

Now, in these workshops, although I'm describing details as I draw them, I am also thinking a couple of steps ahead. I know that shading and stubble will have a part to play in the finished portrait – particularly shading around the eyes, as indicated in our profile photographic reference, due to the 'step back' from eyebrow to the iris. However, you should resist the temptation to draw any of this in now. Note it, but wait until you have all the key points drawn, otherwise your caricature may lack uniformity and cohesion.

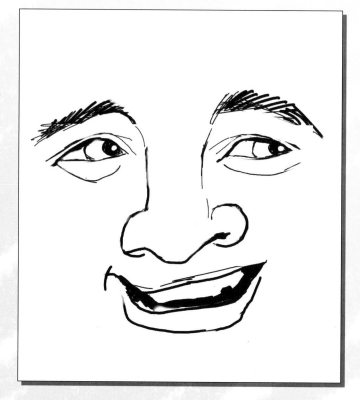

Step 3

My impression of the forehead is that the hairline is a little high, so don't be afraid to reflect that. This subject uses hair gel, which is a great boon to caricaturists, since it allows you to draw that slightly untidy look with the hair. I've been a touch cruel with the ears, but this is, after all, a caricature, and you will always have to work harder with the younger face to avoid blandness. The cleft chin is interesting and is made even more noticeable by the smile.

Now you have all the central vertical features in place, which will help as you visualize the placement of the outline. Don't be afraid to have a go – I haven't done any, what you could call, grotesque caricatures for these workshops, but it may well be a path you take and one which turns out to suit you best.

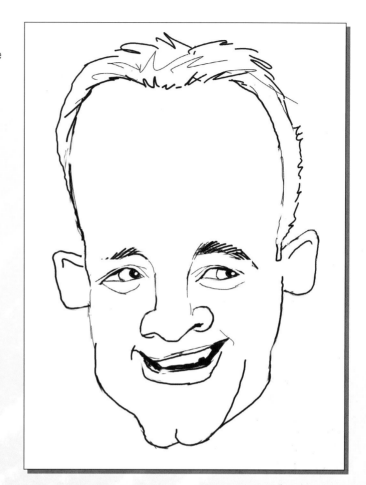

Step 4

Finally on the finished version, use shading, following the curves of the face, always keeping in mind that, where shading is concerned, a little goes a long way. Apply your hatching lightly and economically. Then comes an interesting choice: do you show beard growth that may well be less than a day old? My rule of thumb is, if it is obvious, draw it. Some people either have a strong growth that rapidly produces a shadow, or cultivate designer stubble. However, be careful that you don't overdo it and lose the definition of the main features. You will notice that drawing stubble is identical to drawing shading, so how do you differentiate? You should draw any shading first and then draw in the stubble over the top. It is a delicate balancing act that can be difficult to achieve initially but will become easier with lots of practice. Once again, exercise caution and remember the little-goes-a-long-way principle.

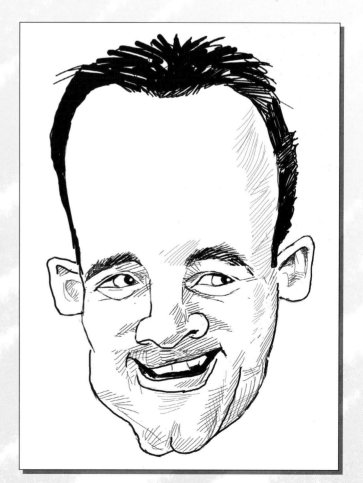

MATURE LADY

Although the subject for this exercise is a mature lady, she has clearly retained many of the attributes of a younger woman, so it is important that however else you choose to approach this portrait, you reflect this in your drawing.

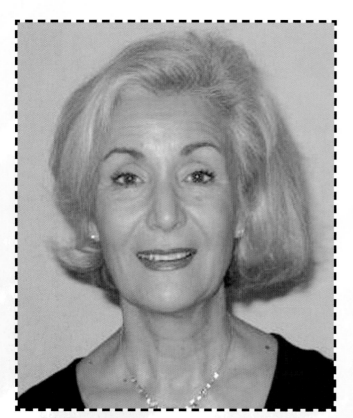

One of the advantages of drawing a woman is that she will always be aware of her best features and will use make-up to enhance and draw attention to them. Blusher, lipstick, eyeshadow and mascara are just some of the potions and lotions used to reinforce and draw attention to prominent features!

A woman will also know how to hide those bits that she would sooner you didn't emphasize! It's not that women are vainer than men, it's simply that they are far more skilled at projecting the image they wish the world to see. This, of course, may not be the image you wish to draw but, until you really develop your caricaturing skills, it is a battle of wits you will surely lose.

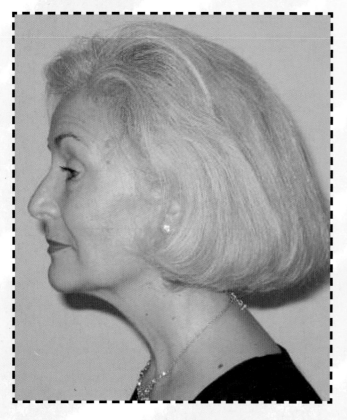

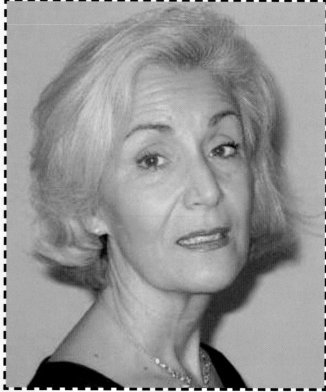

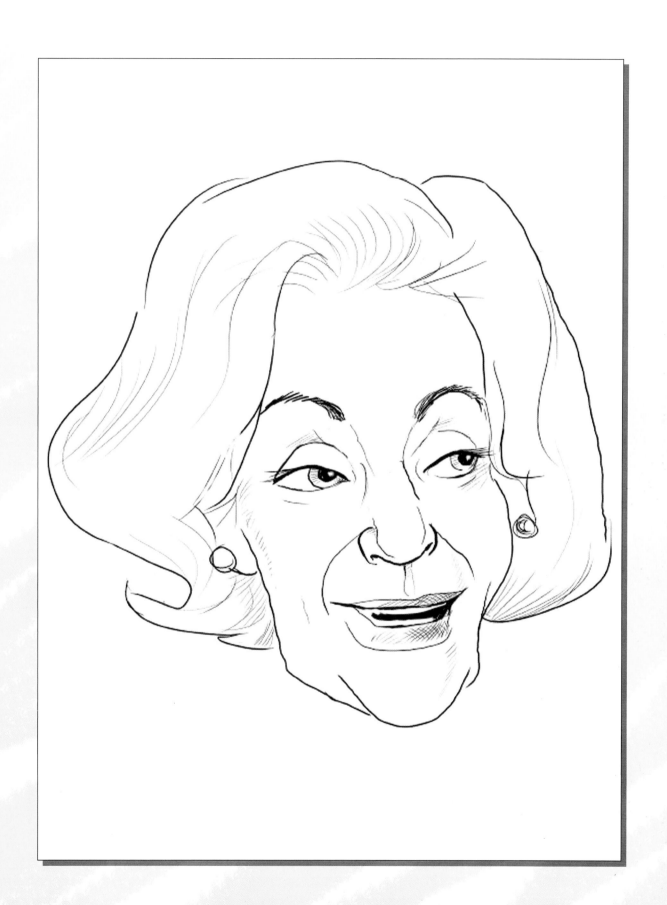

Step 1

I have begun my drawing in the customary way with the T of the eyes and nose. In this instance I have decided to put in the sculptured eyebrows, too, because this will help me to define the bone structure around the eyes. You should always be alert for such helpful features and be prepared to draw them at an earlier stage than normal, whenever they will help in the construction of the caricature.

Step 2

After further development of these features, I add the basic mouth shape. A key point to remember here is that, when drawing such a face, you need to exercise the lightest touch with your pen. Go for the key lines but beware of adding too much shading, the result of which would be a failure to convey the fairly delicate nature of these features.

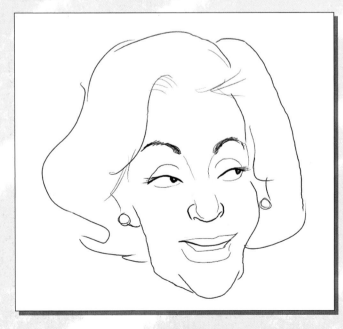

Step 3

Now, we take a deep breath and draw in the basic shape of the hair and the face, moving on, immediately to begin defining the bone structure. Be careful when drawing the chin, and bear in mind our earlier comments regarding the size and position of the female chin – in other words, err on the side of caution. Once the chin is in place, you have a baseline from which to draw in the sides of the face, which in turn allows you to position the ears and the hair outline.

Step 4

This is another critical point of the caricature where overdoing the line work will be detrimental to producing a caricature which reflects not only a physical likeness, but the personality of the subject, too. So, once again, tread lightly with a delicate touch. The intention here is to lift the face by adding a few – a very few – lines that help to clarify bone structure. These lines will form the basis for whatever shading you consider the finished portrait might need.

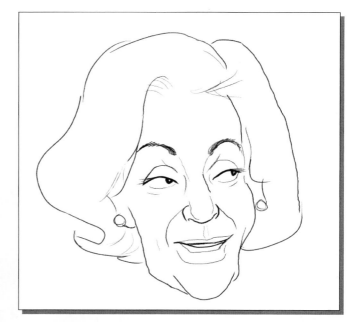

Step 5

Nearing completion, I really want to bring out my subject's distinctive eyes and make them larger than life. I am also balancing tonal values by shading in the lips. Finally, once again using that delicate touch, I add a little more shading, to lift the hair and emphasize the eyes.

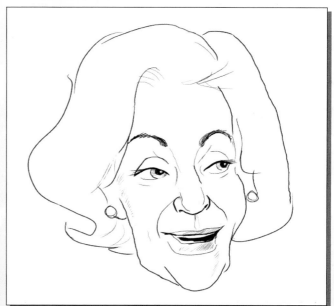

Step 6

At this point take another really good look at the photographs. You should always double check your references before adding the final touches to the hair and face – as you become absorbed in your work, there is always the danger that you may forget to do this and run the risk of loosing a good likeness.

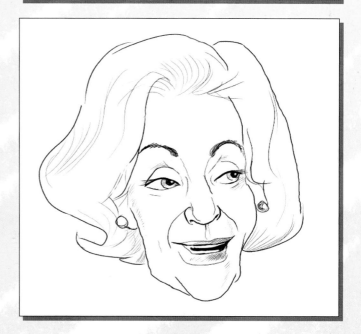

ANOTHER FACE, ANOTHER MEDIUM

I have already touched briefly on the simple use of colour in Workshop 3 (see pages 54–57), and now return to it for this final workshop. This time, instead of watercolour, I shall be using pastels. The use of pastels has a long and distinguished history in fine art portraiture, but its use as a medium for caricature is less well known. It is, however, the medium of choice for what are generally known as court artists, some of whom adopt a caricaturist's interpretation. These are the people who record, for publication, visual images in law courts where cameras are not permitted. In many cases, they produce a stronger image than a camera would, in the way that they capture the drama of the occasion.

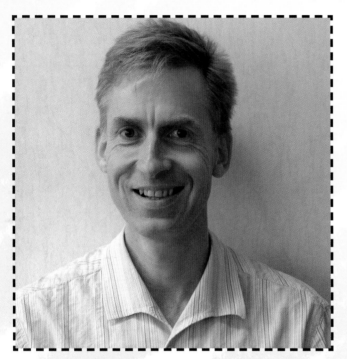

So, why do they use pastels? And why are we offering an exercise in this medium? Some of you might be a little daunted by the idea of painting, and wielding a wet brush, at least at this early stage, whereas pastels are an instant colour medium that can be applied at speed. You can create a colour portrait of sorts with the minimum of fuss, using materials no more intimidating than a coloured pencil or piece of chalk.

What we shall do here is produce a coloured sketch similar to the sort of thing a court artist would produce, as opposed to a measured portrait, which would require considerable skill and experience of the nuances of pastels.

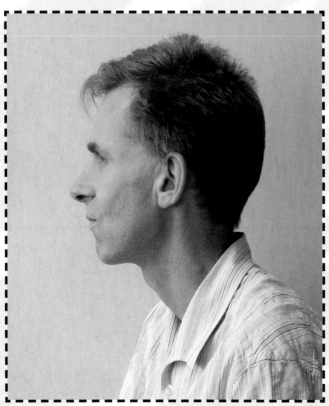

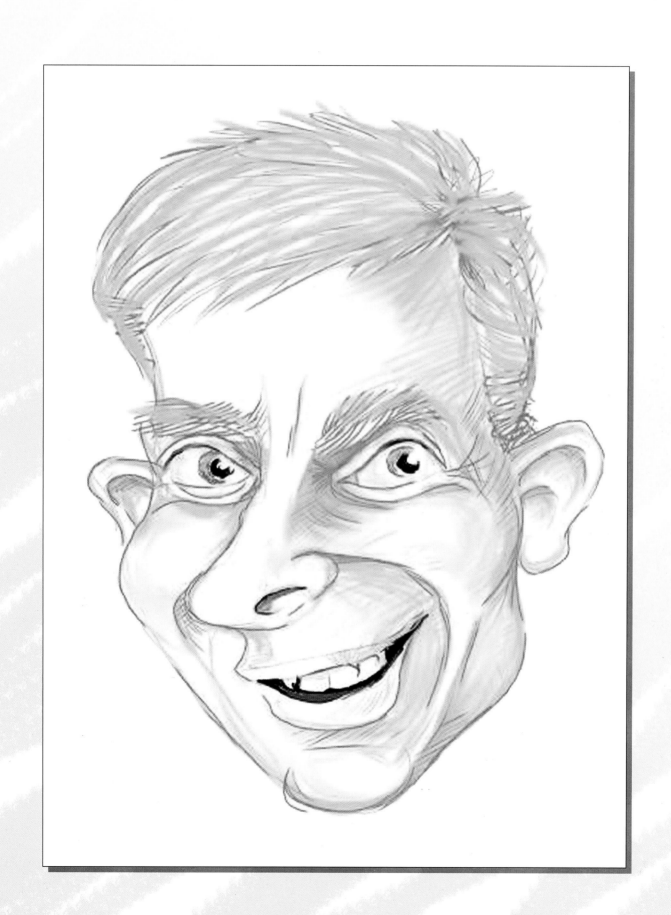

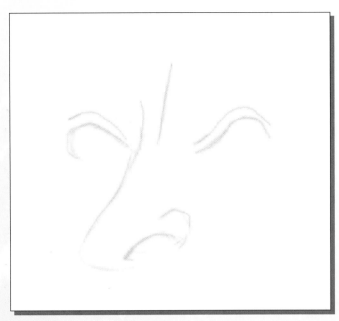

Step 1

First thing to note with this man is his red hair. This almost always denotes a fair complexion so, starting with the usual eyes and nose, I am using a pale, cool red as my base colour. In this exercise we are not using coloured or textured paper, a common background for pastels, which allows us to use white as a highlight colour. So, I am concerned at this stage just to get a few key outlines drawn upon which to build.

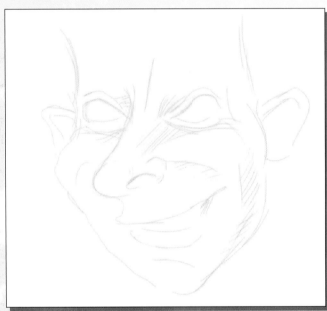

Step 2

I go to work exactly as if I were using a coloured pencil, simply sketching in the lines. With this subject, I am helped by having an interesting face, with plenty of character, to work with. This gives me the confidence to develop this stage more than I would generally do.

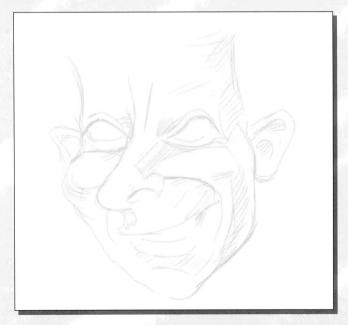

Step 3

I have plenty of well-defined lines to work with and want to go as far as I can before changing colour. The reason for this is that I will blend the hatched lines with a cloth and don't want any dark colours that could smear and spoil the picture at this stage. If you do over-smear any of the pale crimson lines it is easier to hide as you work over the top of them later on.

Step 4

Having gone as far as I can with my pale, cool red, I now use a darker base colour for the hair. I now have two extremes of tone upon which to build, later on, and consider which colours I want to apply next. We have mentioned before how you need to work your way into a caricature portrait, and that there are points when you have to be reassured that you are on the right track. My way, usually, is to finish any work on the eyes, but in this instance I felt that defining the hair and shape of the eyebrows would be enough.

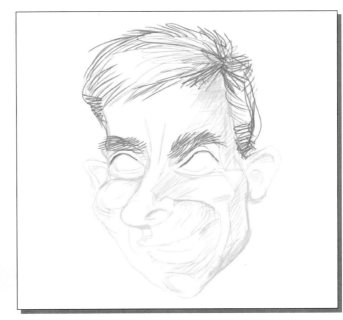

Step 5

I now have a good foundation upon which to build the finished caricature. I add the final hair colour and then blend the pale red, using a soft cloth. Having done that, I can add the details of the eyes and mouth. Unlike watercolours, of course, overlaying colours will be opaque and will not let the underlying colour show through. Because I am applying the colour in the form of line work, however, there are many areas where the darker lines do not cross the lighter ones and the eye of the viewer will blend them. Similarly, the blending with a soft cloth will produce mid tones between the lighter and darker colours that have been used.

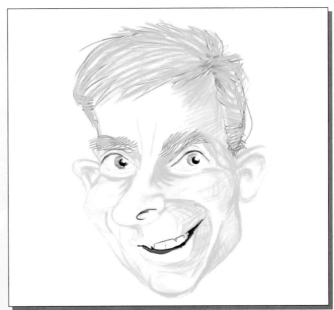

Step 6

With the face now staring back at me, I can approach the finishing stretch with some confidence, and begin the process of adding and blending increasingly darker colours until, finally, I use a sharp dark red pastel to lift the lines that I first put in with the pale red. It will almost certainly take a lot of trial and error, as you get to grips with this simple use of pastels, but it's worth making the effort. And don't worry – pastels are fun to use and you should enjoy the learning process.

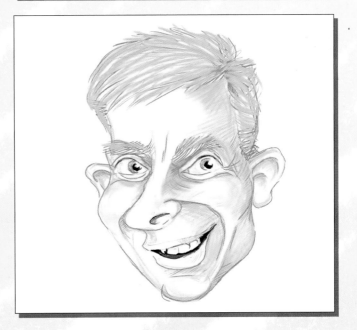

CHILDREN AND TEENAGERS

The golden rule when drawing young people is not to draw them as small adults. Their physiology is totally different with differing aspects that are in a state of perpetual change. If you fail to bear this in mind it is quite likely that even if you get a reasonable likeness, the face will look too old. The eyes, as we've discussed, are a stable and developed area upon which to start and, with the two examples we have here, form the key to capturing a good likeness.

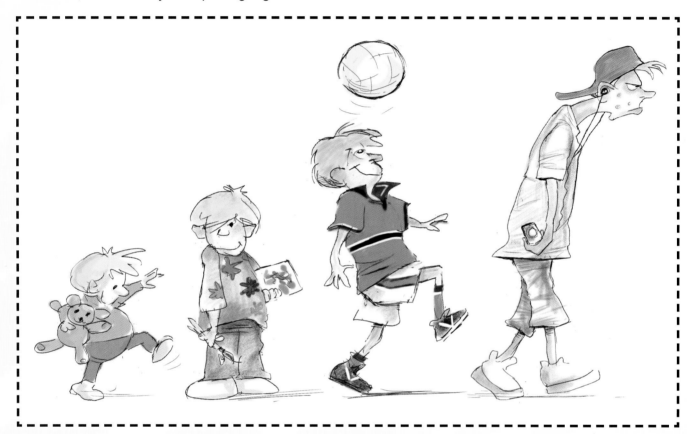

This section is different from the previous ones in that we are not concentrating on a single face. Instead, we have combined two subjects in a single exercise. Whenever you draw children, whether it be a caricature, a cartoon or even a formal portrait, you will become aware that, as partly demonstrated by the illustration on this page, your subject is in a constant state of change. You need to be aware how young people develop not simply at a bone structure and hormonal level but mentally as well.

For instance, as children grow into their teenage years, that spurt of sudden growth upwards seems to affect their centre of gravity. They go from being able to bounce around without a care in the world and with a natural balance, to a sort of gangling awkwardness. This rapid readjustment to their centre of gravity can influence their confidence as well as their posture and poise, leaving you with a subject that can be at times both hostile and insular.

Happily, neither of our subjects opposite are demonstrating any of that angst and hostility, despite the fact that our young boy was a rather reluctant subject! A teenager who is really interested in having her caricature drawn and a young lad who is reluctant and shy may be an exception to the rule but, luckily, this switch around will not impede us here. By putting these two contrasting children together and working on them in tandem, we hope you will see more easily the approaches taken with these two age groups.

It's worth pointing out that the young man we have here wasn't, to put it mildly, very keen on being photographed! It took a deal of persuasion from his family and even then, you can see that he'd rather be doing something else. So the secret, as always, is to be quick with the camera and even quicker with the pen if working from a live subject!

Children and teenagers can feel even more insecure about caricatures than adults so, whilst avoiding drawing a bland portrait, try not to be too unkind. Braces, blemishes and any other 'temporary' features should be left out altogether. It's a fine dividing line and I'll try to show how I interpret that line in a way that will inspire you to try.

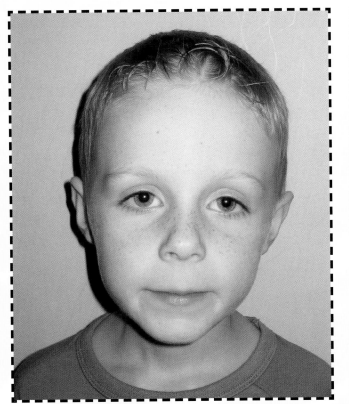

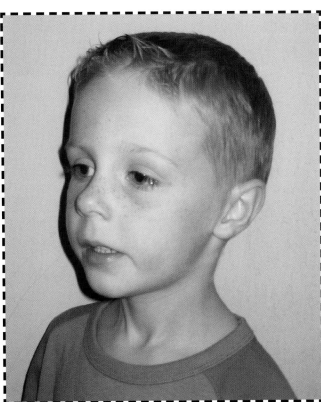

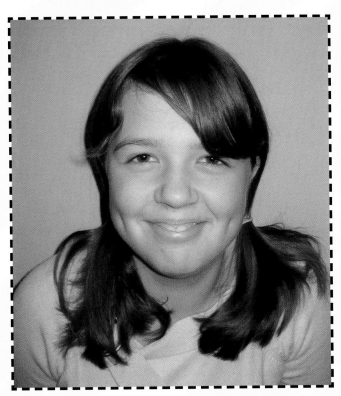

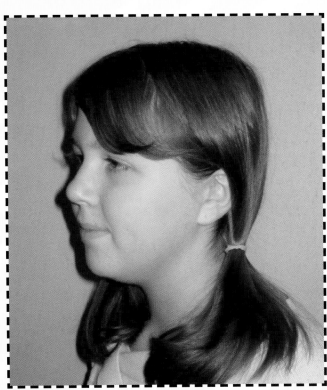

Now, getting back to our models, although the eyes are nicely in place, beware of drawing the nose too big – with children, always err on the side of caution and go smaller. I've done both of these caricatures in the classic three-quarters view to make the most the noses and the chins.

It's important to keep the line work simple with children. Shading should be kept to an absolute minimum to avoid ageing your subject. A few simple lines are all that have been sketched so far but already a clear likeness is starting to emerge. I've drawn the eyelid line a little heavier here than I usually would, to give them that doey-eyed look so common in the young. Both children have small noses, and the boy's turned-up nose has been exaggerated slightly to emphasize its cuteness. Note how the young girl's eyes have been given a little bit of sparkle to give away the fact that she is happy and smiling.

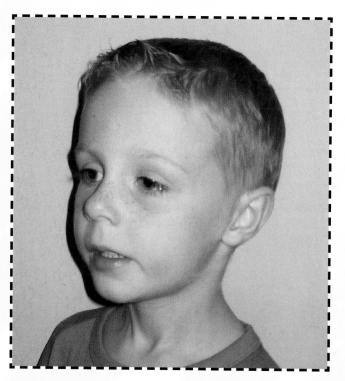

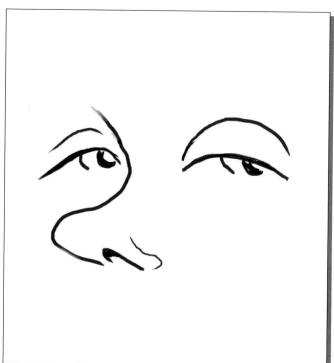

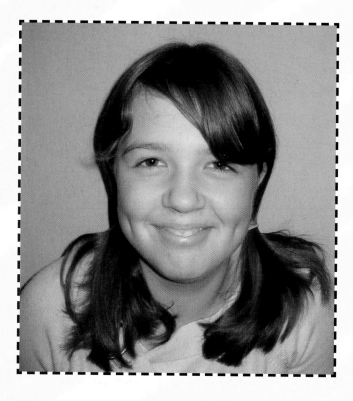

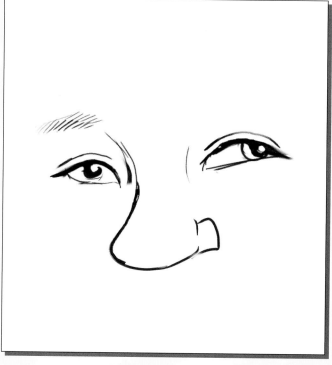

When drawing the chin, draw it, then erase it and do it again 50 per cent smaller! In my experience, the single biggest problem with caricaturing young people is that the artists usually draw the chin too big – and this adds years to the age of the subject. If, on the other hand,

their ears look big, then draw them big. This is simply because ears are one of the first features to grow to adult size and, as with getting the chin right, will age your subject perfectly. Again, I've kept the line work simple – don't feel the need to get bogged down in detail.

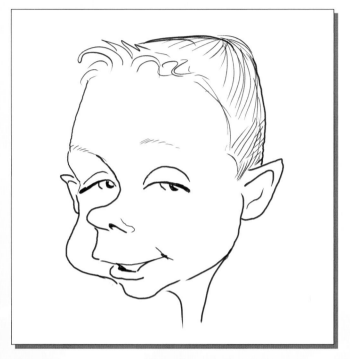

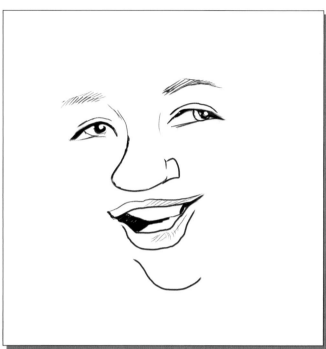

Freckles? Draw them by all means if they are obvious – I find that two short parallel lines work much better than single spots, but don't get carried away and draw too many!

I've added a couple of short lines around the cheek area to convey our model's dimples Dimples always make you look younger than you are, so make the most of these features, especially when drawing young children.

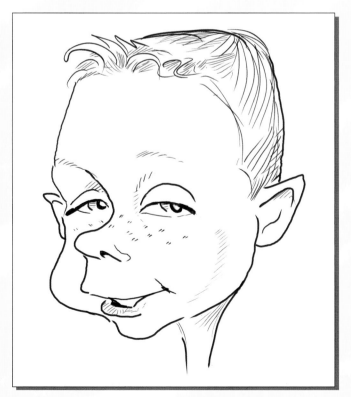

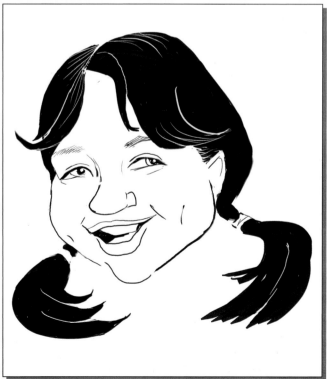

If you draw the whole body, be careful about the size of the hands – as with the nose and chin you need to be wary of giving children adult attributes. You must also avoid the trap of turning your caricature into a cartoon.

A cartoonist will often simplify the hands (of adults as well as children) by drawing only three fingers and a thumb. With caricatures, however, you should always draw the full compliment of five fingers.

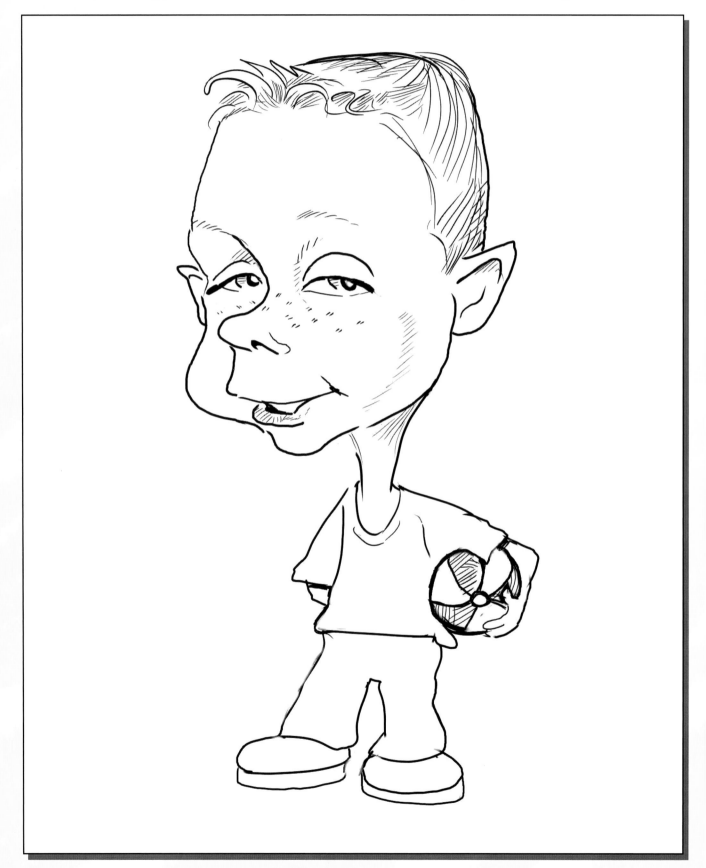

You'll notice that I've animated the hair as a way of adding life to the picture. Hairstyles are matters of some importance to younger people so be prepared to spend some time on getting it just right. I've drawn the girl so that she is on her mobile phone, which is often surgically attached to teenagers! Don't be afraid to improvise when it comes to props! There is only one more thing to say about drawing children – good luck!

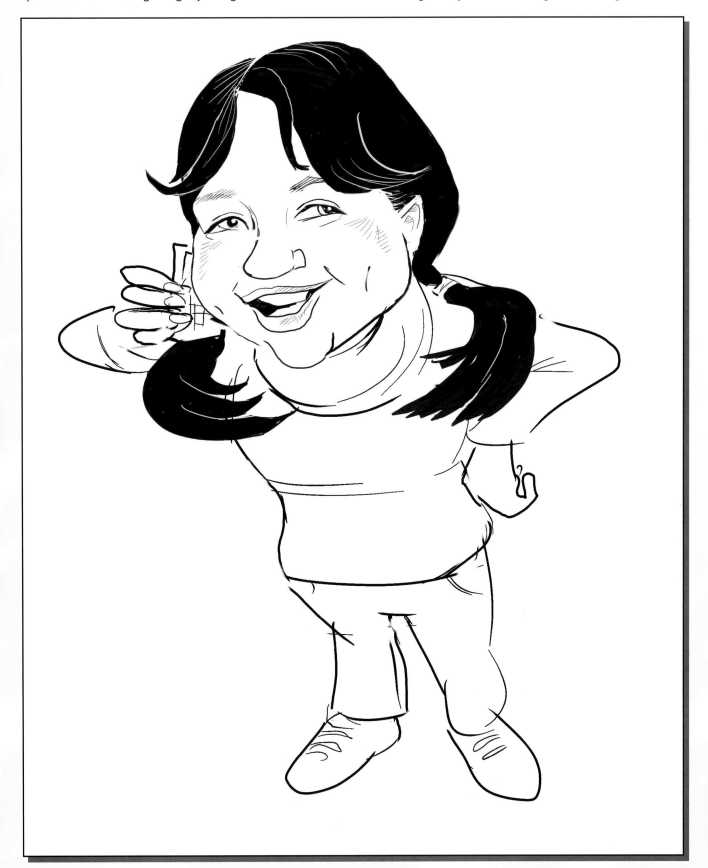

BABIES

Although not a common occurrence, sooner or later you will be asked to draw the caricature of someone's baby – and babies, it must be said, are not the easiest subjects to caricature, particularly if you are required to draw them in a live situation. A baby's attention span is extremely short and they will change expression frequently, and quite drastically, in milliseconds. Likewise, a baby's mood can change from happy and gurgling to distressed and howling in the blink of an eye.

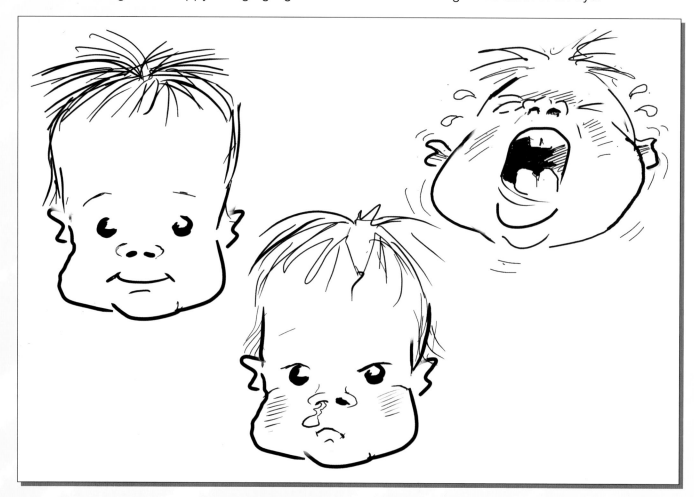

If you have no other choice than to draw live, ask someone the baby is familiar with to hold him or her and ask the mother or father to stand directly behind you so that the baby will look in your direction. You can also try calling the baby's name, although if this works it may only do so once!

As you will have gathered, drawing from any live model requires that you work quickly, but this applies even more so when caricaturing a baby. It isn't altogether a bad thing – you have little in the way of features to work with and a guaranteed way to produce a less than successful caricature of a baby is to overdo the line work. However, wherever possible with babies, you should try to work from photographs, as we are doing for this session, the subject of which is a pretty girl celebrating her first birthday.

You will recall from Facial Basics (see pages 28–43), that the eyes are the one feature that changes the least as we age: that the eyes should be the bedrock on which to build the face is a rule that applies even more to babies and young children than to adults. You should make the eyes slightly larger than normal for two reasons: firstly because they are the most developed feature on a baby's face, and secondly because if you inadvertently oversize some of the other features, the result may not be too adversely affected. This is actually the greatest danger when caricaturing the very young – drawing the nose, chin or indeed any feature other than the eyes, oversize. Doing so can age your subject by a year or two at least. Also, bear in mind that whatever your style and approach, with young faces you need the lightest of touches with all the line work. So, let's get started!

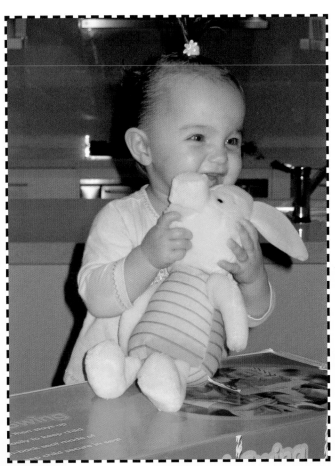

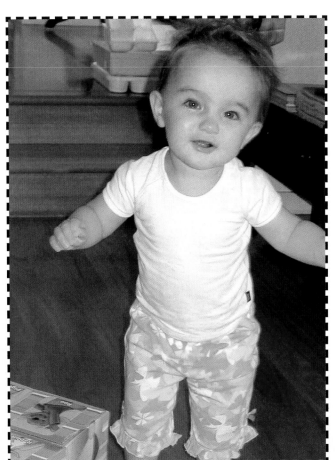

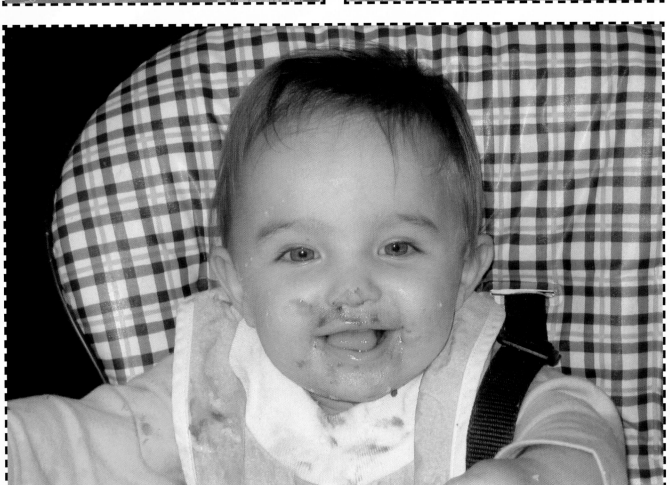

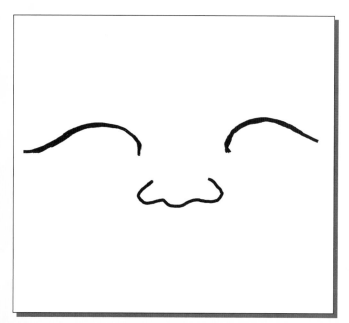

Step 1

First impressions, as we have said previously, count for a lot and of the three pictures, here, I am using the one showing our subject's exuberant eating style as my main reference, whilst using the others as references for specific features. In this picture she is happy, interested and focussed on the camera.

Your first lines should be the upper eyes. You will note that I have also positioned the shape of the nose, keeping it small.

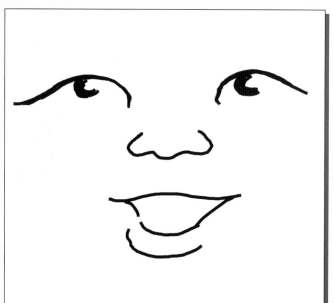

Step 2

Because we are drawing the eyes larger than normal, position the irises next, then carefully – very carefully – draw in the top lip followed by the two lines that make up the bottom lip.

The space between the upper lip and the nose is crucial for all caricatures, not just babies. It is one of those points that define the face and one of the most common problems for the novice – and even the more experienced caricaturist. Always keep in mind that the spaces in a drawing are just as important as the lines.

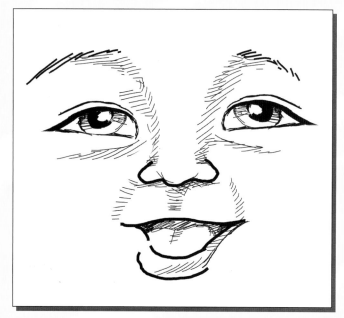

Step 3

In most adult caricatures, at this point I would normally be thinking about drawing the outline of the face. With a baby, however, you need to develop these initial features a little more before committing to the overall shape. You can use a little delicate shading, taking special care not to 'age' the baby's face with over-exuberant line work.

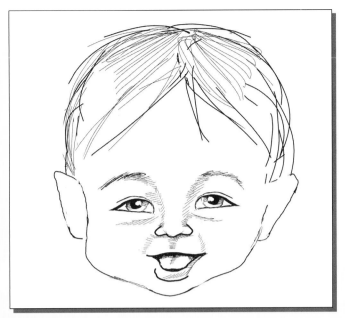

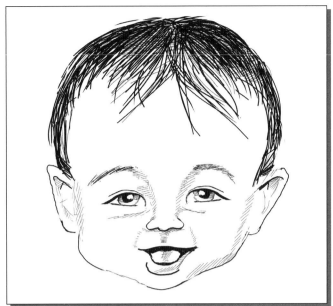

Step 4

At last we are ready to give a shape to the face. There are two things to watch out for here. Firstly, bring the chin up close and keep it small and, secondly, be generous with the size of the forehead and the hair. We are reaching that by now familiar stage where your subject is beginning to stare back at you from the page.

Step 5

Once again, it is crucial here to draw with the lightest of touches, being careful not to overdo anything. Be particularly careful with ears – just give the impression, the merest hint, of detail. Now is a good time to pause and re-examine all of the photographs. This is the point at which I would go for a break and then go over the details of the face to see what features might need a slightly more weighted line to give them greater emphasis.

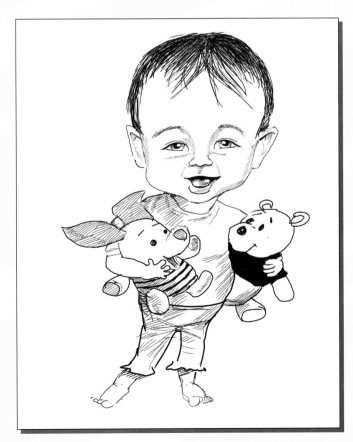

Step 6

Finally, with young children, add a body, but be extra careful not to make it look like a rag doll tagged on as an afterthought. (This is also good practice for hands, feet and posture.) It is traditional to draw the head larger than the body with this type of portrait. This is mainly because, with babies, things like posture and mannerisms are not developed to any great extent and using the body as a major recognition characteristic is difficult. Better, then, to concentrate on the head, whilst still using the body in conjunction with correct clothing and favourite toys, to achieve a good likeness. And when you have done all that, it is time to hold your breath and wait for the baby's parents' faces to break into smiles! It is unlikely you will ever face a more challenging job than that of caricaturing a baby.

DRAWING IN PROFILE

The profile caricature has been in and out of fashion many times over the centuries, last enjoying popularity in the years immediately prior to World War II. It was often the angle of choice for many of those caricaturists involved in Theatre Caricature, where celebrities of the day were portrayed on the walls of the café society.

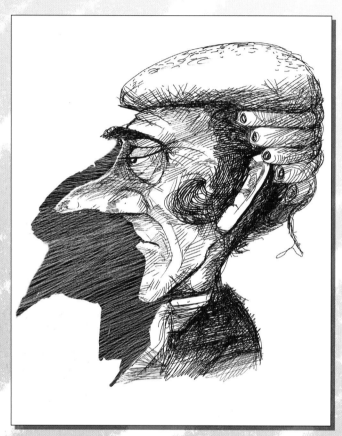

When producing a profile caricature, there are certain differences from the full-face or three-quarter viewpoint to bear in mind: certain key lines may rise to prominence, such as the shape of the nose, whilst others, like the look in the eyes or turn of the mouth, may recede. Drawing a caricature in profile is one way to bring out certain of your subject's characteristics that might be masked when drawing from a more regular angle – a ponytail, for instance.

One of the immediate problems with drawing a profile is that subjects will rarely recognize themselves, as it is a view they are not familiar with. However the advantage for an inexperienced artist is twofold: firstly you won't be intimidated by the sitter trying to peer at the work and pass comment before it is finished and, secondly, having a distinct outline to follow will aid your confidence.

So, let's run through the creation of a profile caricature and explain some of the reasons for choosing this approach.

Our subject for this exercise is well known for wearing a baseball cap – almost to the point that his friends suspect it is surgically attached! Whenever you have a subject who is known for a particular style of attire or posture, you must, of course, try to include it as a recognition point. The problem with baseball caps is that they are awkward to draw from the front. In a profile, however, they work really well – you can then treat them like any other facial characteristic, exaggerating size and importance. Unless your subject is especially well known for wearing a hat, however, drawing headgear is best avoided. A hat hides the overall shape of the head and the hair detail and, hopefully, the subject will treasure their portrait far beyond the life of a particular hat.

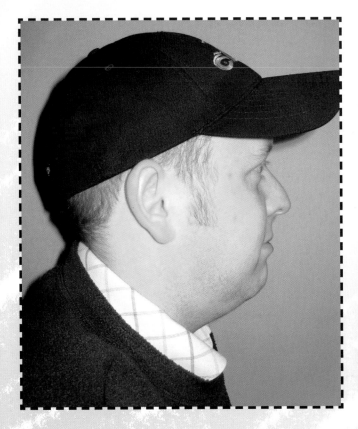

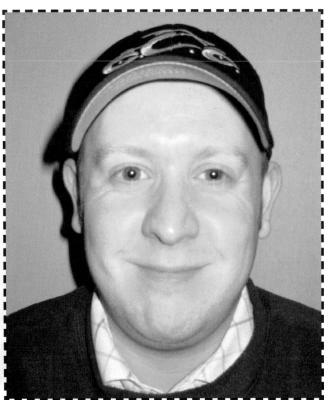

Take some time to examine the photographs we are using as our references. In this case, you can probably see that a full 90-degree angle wouldn't work so well, as some of our subject's key features are masked by his cheek. So, we have opted for a very slightly rotated angle that maintains a profile but opens up the face a little more.

With a profile caricature, it is still a good idea to start with the eye, and immediately you see one of the advantages of drawing from this angle because only having to draw one eye means that you don't have to worry about symmetry. Think of the eye as the central point around which everything else revolves. You will notice that we have drawn the eye looking directly towards us – usually a good approach because the subject will then be returning the gaze of any viewer of the caricature.

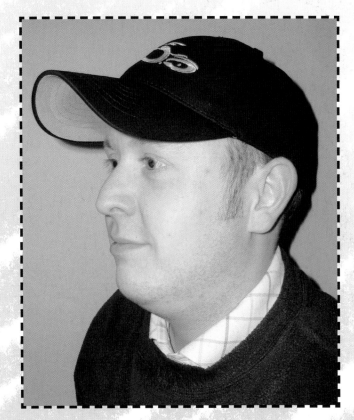

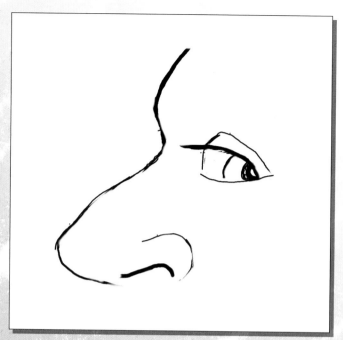

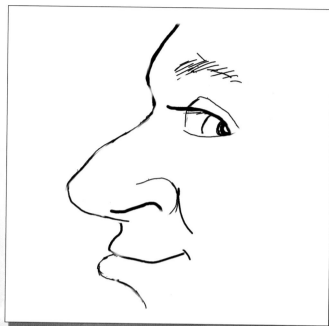

Step 1

Draw in the shape of the nose. You might consider I have drawn this slightly larger than is warranted, but you shouldn't rely entirely on the photograph that is being used as the profile reference. If you look at the full-face reference, you can see that the nose is actually bigger than it appears to be in profile, so I have tried to reflect, in profile, its overall importance as a recognition point. You may disagree with this but don't worry, that is allowed! The style you develop is as much about what you consider relevant as the way you draw.

Step 2

Moving on, I want to show that slight smile that raises the cheek and softens the expression. The mouth is drawn with the bottom lip jutting out slightly and this is also a good time to draw the peak of the cap – it gives you a constant straight line that helps you to develop the shape of the cap and to draw the outline of the face. Notice how I have used the line to follow the shape of the cheek. By now you should be getting a feel for the portrait.

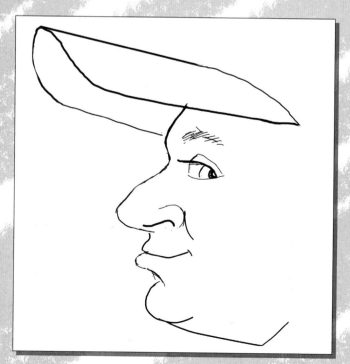

Step 3

That slight smile with the single eye and the profile nose will tell you if you're on the right track. Because there is less line work in a profile, don't be afraid to erase lines and start again whenever you feel you haven't got it quite right. If you have real doubts, but still push on regardless you will probably find it difficult to achieve a good likeness.

Step 4

At this point, as we draw the ear, it is easy to become tied down with detail. Keep it simple, and just pick out the more obvious lines. We have given more weight to the line of the lobe because it sticks out slightly. The sideburns also help in this regard, working as foundation lines.

The lines of the cap provide a good base line for placement of the ear and, from there, the sizing of the face with the inclusion of the chin.

This is one of those points when you will find it helpful to step back and examine what you have done – in fact you could even leave the work for a few minutes and then look at it with fresh eyes upon your return. It is surprising how often doing this will instantly bring to your attention anything that isn't quite right with your drawing.

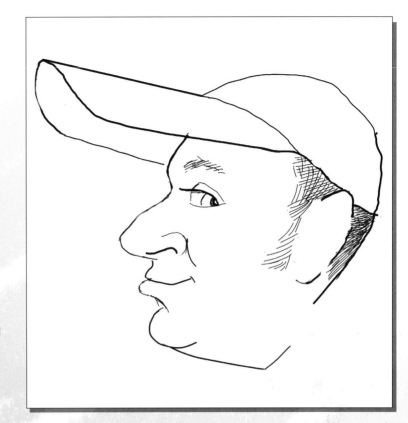

Step 5

Finally, because this is a young face that doesn't have many angular corners, we have used a shadow from the cap to highlight shapes and curves within the portrait, specifically those of the forehead and the nose which, without this shading, might tend to look a little two-dimensional in this side-on view.

Drawing caricatures in profile is not the norm, but now you can understand why this angle is sometimes a very good alternative, if not the best.

If, for instance, you ever feel intimidated by your subject, or they are constantly trying to see the work as it progresses, moving them into a profile position should solve the problem.

DRAWING A GROUP CARICATURE

So far we have discussed only single portrait caricatures. The natural progression from these is the group, or team caricature. A group, or team, can comprise family members, work colleagues, sports teams, in fact, any group of people who share a common purpose, interest or status. The size can be anything from two people to two hundred! As your caricaturing develops and improves, sooner or later you will be asked to draw (or be commissioned to draw) such a portrait.

Rembrandt's *The Nightwatch* is typical of a status group portrait. It is no comfort to know that the great masters from history had more than a few problems when commissioned to produce such portraits. Examination of such works frequently reveals figures removed, added or positions changed. We're sorry to say that nothing has changed with time! In a group of any size there will be at least one of the subjects who will fail to see themselves as you see them and who won't be completely happy with your portrayal!

It is easy to blame yourself and your lack of experience, but this happens to even the most skilled caricaturists. In fact, there are some people who simply don't understand the caricaturist's art at all. Others, whilst not liking their portrayal, may find that it grows on them in time and may well say something like, 'I didn't see it at first but now

I understand what you were getting at, and it has pride of place on the wall.'

What we are saying is that, drawing a group, you are much more likely to encounter some of these difficult subjects than with single portraits. There is nothing you can do about it, so don't let it worry you too much. So, where do we begin?

First thing to find out is what the person commissioning the artwork actually has in mind. Look at usage – they may want to give every person in the group a copy the size of a standard letter, and this could prove awkward if there are, say, two dozen people to fit in. Or they may want something the size of a wall! The point here is that good communication at this point can save a lot of aggravation and needless modifications later.

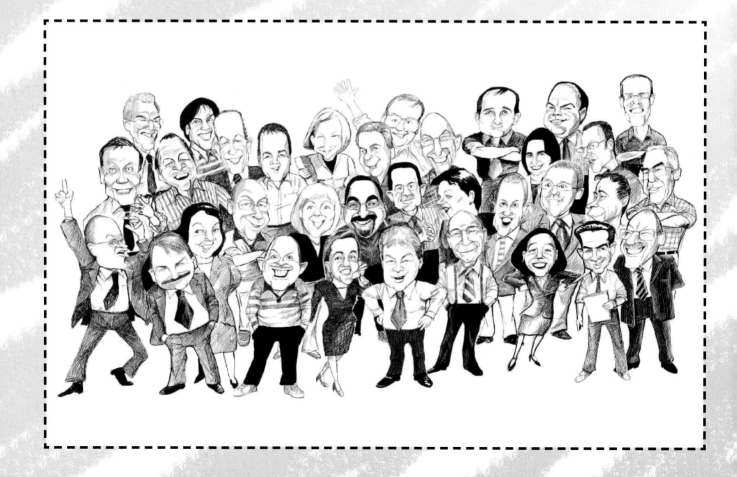

Put people together in a group and they will interact. The body language might be fairly subtle but people don't simply stand there like ten pins in a bowling alley. As a caricaturist you become skilled at people-watching and the observation of body language. Any team, by definition, will have an undercurrent of cohesion. Look for it and try to mimic it. There is usually a pecking order, especially where the team comprises members of staff.

You can glean a great deal from the position and stance individuals take in any group photographic reference you take or are given. With business orientated teams, however, the odds are against you getting everyone together for a group photo to work from, so it is prudent, if you have to work from separate photographs, to clarify with the client any 'who want (or don't want!) to stand next to whom' issues before you begin! This can also be a very important point in family groups, too. You should start off by producing an outline sketch showing where you intend to put people. Draw the heads first, as rough egg-shaped outlines. This will allow you to get the balance right, after which you can then add the bodies.

Suggested group layout

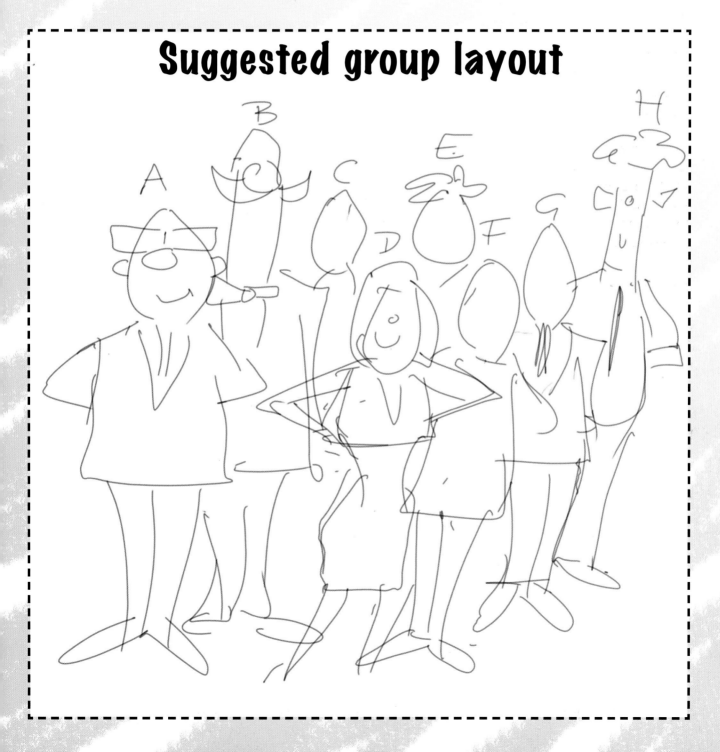

Just one word of caution, here, with regard to working from photographs of people with whom you are not personally acquainted. Photographs are not necessarily very reliable and will often fail to show relative heights and other important details.

Of course, the first group caricatures you will draw are more likely to comprise family and friends. There are considerable advantages to drawing these groups – you will know everyone and they will probably be readily available to pose for you. They are also likely to be fairly tolerant of any inexperienced shortcomings in the artwork. As mentioned, relative height in a group situation is an important consideration especially with drawing different generations together so, again, try to produce a rough layout as a guide before drawing in the individuals separately.

At this stage, there is no need for you to concern yourself with the detail, drawing in just the basic shapes is all that is required. The object of the exercise is to achieve a balance that is easy on the eye – notice how, in this example below, all of the people, with the exception of the baby, are fairly equally spaced. Having some members of the group sitting and others standing, with children filling the gaps, not only helps fit everyone into the drawing but also makes for a much more interesting composition. Note also, the effective use of 'props', such as the football and the hats – even the baby fulfils the role of a 'prop' in the way in which it is being held. Varied postures also help to make a group look more interesting.

A really important point is to remember to keep the group fairly tight. Any individuals that appear detached could be interpreted as being just that – not a part of the group.

Rough layout

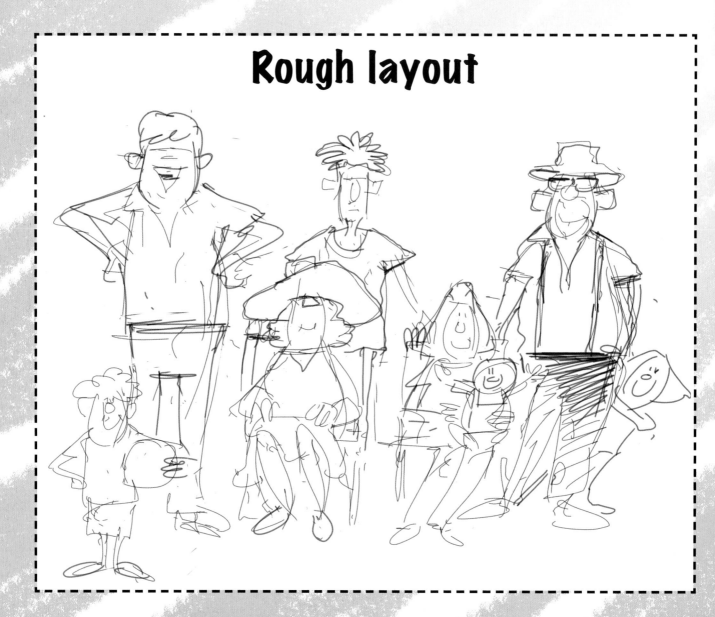

Despite the problems we have mentioned, producing a group portrait that is well received will give an enormous lift to your confidence and will always be worth the effort.

With your new-found skills and confidence, maybe now is the time to consider applications for the group caricature. One of the most popular requirements is the corporate Christmas card. Portraying a team, for instance, in a festive environment, adds a challenge to the caricaturist's skill. These two examples show what can be achieved with a little imagination.

Weddings offer another excellent opportunity for group caricature. In fact, for the professional caricaturist, weddings are quite a growth industry. One good idea, when drawing at a wedding, is to draw a large caricature of the whole of the top table at the reception. The guests can then all sign it and it will make a lovely memento for the happy couple.

Generally, at a wedding, everyone will be dressed up to the nines and looking to enjoy themselves, providing a rich harvest for the caricaturist. Remember to make the bride happy and glowing and try not to be too unkind to the mothers, regardless of how ridiculous their hats may look! And, most of all, bear in mind that weddings often take place in the afternoon or the evenings, which gives some of the less self-disciplined guests rather too much opportunity to take advantage of the alcoholic beverages on offer. Drink and caricatures do not mix; there are few things more futile than trying to draw someone the worse for drink so avoid doing so at all costs!

If you are lucky enough to be asked to produce a group caricature for a poster or a programme for a play or film, this can provide a different challenge. You will need to produce good likenesses for the actors and also for the characters they are playing. You will also need to try to give a flavour of what the play or film is about. Theatre poster artwork is usually reproduced by the venue where a play is to be shown and such an opportunity is to be prized since a caricature produced for this purpose will be seen by a large number of people. It is also likely to be used in their season's programme, so you would have to think carefully about how the drawing would look when printed at a much smaller size. Producing caricatures for professional theatre posters may seem a long way into the future for you at this stage, but, as with everything, you can always gain experience in a small way – offering to do something for the local amateur dramatic society, for instance.

Other than the points we have already made, producing a group caricature is not a lot different from producing a single one. Having sorted out where everyone is standing, just take it one person at a time and don't be put off by the size of the job.

CARICATURES IN A CARTOON CONTEXT

The majority of the caricatures you draw are likely to be portrait style, where your subject is the main feature of the work. This is the normal format for caricatures intended as, for instance, gifts to celebrate a birthday, a wedding, job retirement, leaving, promotion etc. Similarly, live caricatures of individuals or, in some cases couples, would be drawn in a portrait format.

There may be occasions, however, when you might wish to include a caricatured figure or figures within a cartoon scene featuring other non-specific or generic cartoon characters. In such cases, it is very important that the caricatured figure should be drawn in a similar style and treatment to the other cartoon characters, in order to avoid a visual clash. Were it to be drawn in a different style, the image would look unnatural and isolated in the viewer's mind, and would detract from the intended interpretation of the caricaturist. In other words there should be nothing in the artwork that causes the viewer to question why one character would look so stylistically different from another.

An excellent example of how this type of caricaturing works successfully can be found in the American TV animation show, The Simpsons. Various mega celebrities have made guest appearances in the programme, 'appearing' as themselves, but the animation artists have used pretty much the same scale and drawing treatment as they have used for the fictional characters, thus ensuring that the guest characters fit seamlessly into the cartoon world of The Simpsons. Of course, the creators are assuming that the viewers are familiar with who these guest characters are, otherwise the gags and storylines would not make a lot of sense.

This sort of celebrity caricature can also be found in political and editorial cartooning, normally the preserve of the professional cartoonist. To create recognizable caricatures on a smaller scale is quite a skill and anyone hoping to master this format will need to learn to pick out the individual characteristics that distinguish one person from another and minimalize the amount of detail that might go into a larger, portrait type of caricature. When drawing these smaller scale caricatures, individual body posture, size and shape, in addition to the facial detail, will come very much into play in helping to identify the subject to the viewer.

The novice caricaturist needs to resist the temptation to put too much detail into the drawing – easier said than done, when trying to capture a good likeness of your subject. Knowing when to stop will come with experience and practice, practice, practice! – certainly, the old maxim, less is more, couldn't be more appropriate with this type of caricature.

'COULD YOU DRAW MY DOG, PLEASE?'

Yes, sooner or later, you will be asked this question, or one similar. And why not draw the family pet? Animals, just like people, have personalities and eminently caricaturable features. Their posture is also often a gift to the caricaturist. Whilst not offering a tutorial on animal caricature here (to cover every variety of pet would require another book) we still think it worth mentioning as another direction in which to extend your burgeoning caricaturing talents.

When caricaturing an animal, just keep in mind everything you have learned from drawing people. Eyes, ears, noses – the rules for animals are very similar, it's just that shapes may differ. In many ways animals' features offer even more help to the caricaturist; a dog's ears, flying in the wind, for example! Here's just one sample of what can be achieved and how the character of an animal can be captured as well as, if not better than, a human subject. There's an added bonus, too, your subject will never criticize the artwork – you hope!

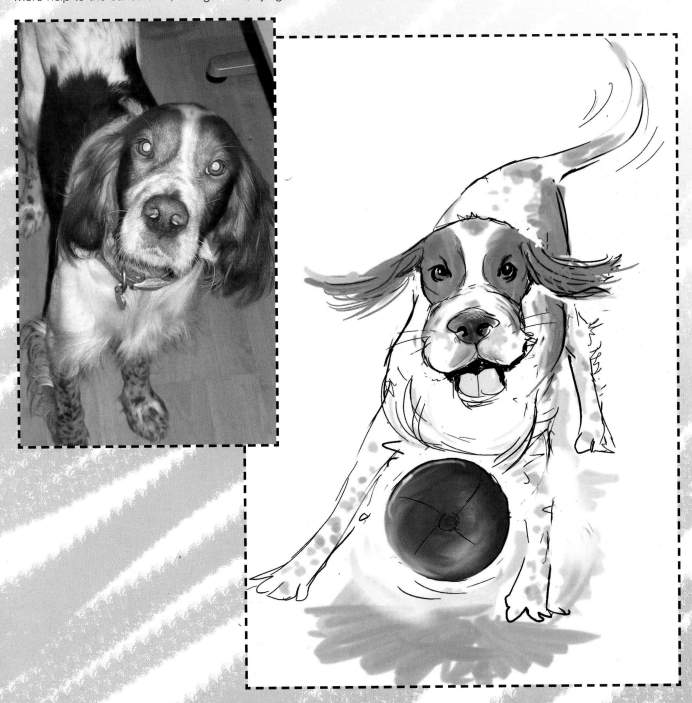

ETHICS AND PITFALLS

If you look at the work of many political cartoonists, you could easily be led into the belief that caricature is a very cruel art. Politicians are certainly given a hard time by editorial cartoonists who often revel in singling out and exaggerating, often in grotesque fashion, every unflattering aspect of their victim's persona – sometimes even adding a few new ones for good measure! Strangely, the politicians usually don't mind and, in fact, are often eager to purchase the original artwork!

In the regular world of caricature, however, in which the majority of artwork is fairly benign and is meant to flatter or, at worst, gently amuse, it is highly unlikely that the subject of such treatment would be happy to see themselves depicted in such a derisive manner. So, from your point of view, the subject of ethics becomes an important one whenever you draw friends, relatives or anyone else who either wishes to have a caricature done or who is going to be given one.

If you draw caricatures long enough, sooner or later you will be confronted by a subject who is, for instance, wearing a badly fitting wig or toupee. You then face a moral dilemma – do you draw it to gracefully blend in with whatever real hair may be showing, or do you draw it as a dead cat sitting on a bald head?

The solution probably lies somewhere in between, but should be based on your knowledge of the person. For instance, it may be that your subject wears the wig or toupee without concern – maybe even draws attention to it themselves. In this case, your job is made a lot easier. Beware, also, of being too generous. Ignoring a negative feature altogether is likely to backfire on you since doing this will emphasize it just as much as if you had exaggerated it! The safest rule to follow is honesty without cruelty. In any case, as a caricaturist you are a people-watcher and you will soon learn to sum up your subject quickly and draw accordingly.

A toupee, of course, is something that your subject has chosen to wear. But what if a sitter has a noticeable blemish or disfigurement – something which is there as a result of fate rather than choice? Again honesty without cruelty is usually the best policy. That scar or flaw is, after all, a part of who your subject is and ignoring it will only serve to make them even more self-conscious. So draw it with care and subtlety, at the same time taking care to emphasize your sitter's more positive aspects. Here, just simple things like the pressure you apply to the pen and the boldness of the line will make all the difference.

Sometimes, the impairment may be temporary, such as braces on the teeth of a teenager. In this case, ignore it – a cruel caricature at this stage can do much to damage self-confidence. Similarly with other temporary blemishes such as spots, bruises and stitches.

Naturally, all cases will not be as clear-cut as the examples above, and you must also remember that the last thing you want to produce is a bland caricature. A good caricature will always have a certain degree of edge – how much edge is up to you. Just be aware of the power that you wield as a caricaturist and try to use that power wisely!